THE
Archive Photographs
SERIES

BIDDULPH

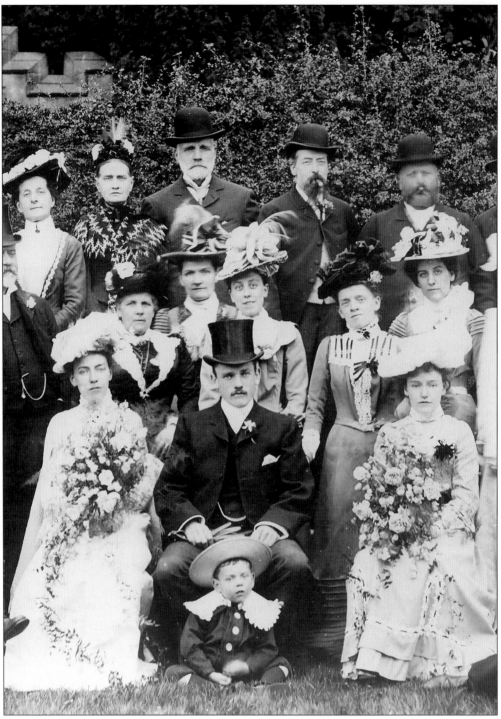

Part of a wedding group at Biddulph Parish Church, *c.* 1900. (see page 121)

THE
Archive Photographs
SERIES

BIDDULPH

Derek J. Wheelhouse

TEMPUS

First published 1997
Reprinted 2004
Copyright © Derek J. Wheelhouse, 1997

Tempus Publishing Limited
The Mill, Brimscombe Port,
Stroud, Gloucestershire, GL5 2QG

ISBN 0 7524 1017 2

Typesetting and origination by
Tempus Publishing Limited
Printed in Great Britain by
Midway Colour Print, Wiltshire

*I dedicate this book of Biddulph's past to my grand daughter
Sophie Victoria Wheelhouse Hulme, who, one day, may become part of its future.*

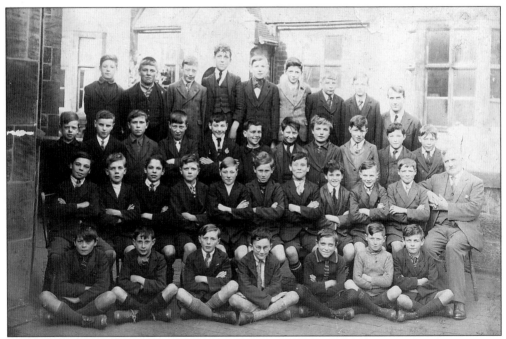

Children from Knypersley Council School in 1927, after Mr George Lawson, headmaster, moved there from Biddulph North School. (see Schools)

Contents

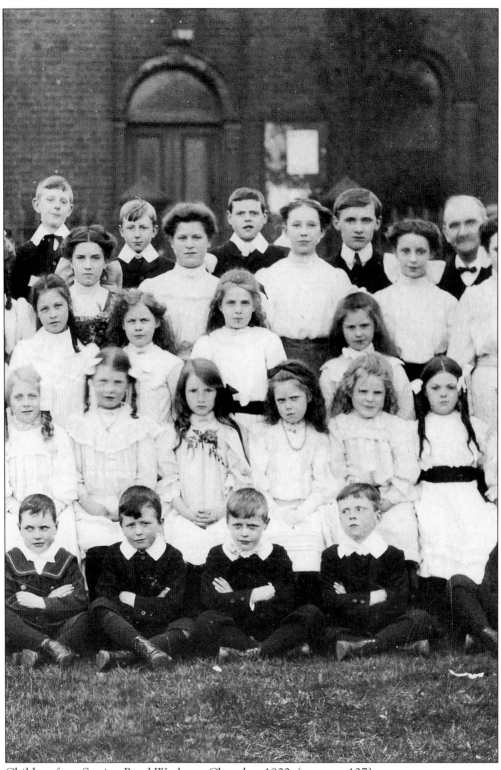

Children from Station Road Wesleyan Chapel, *c.* 1900. (see page 127)

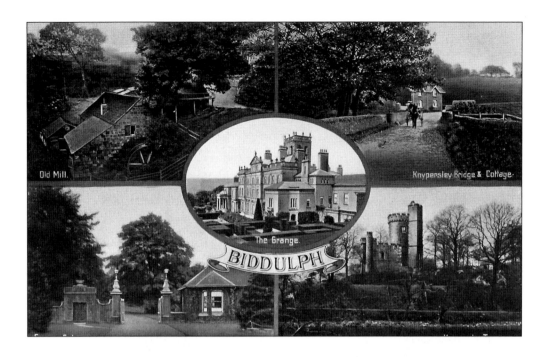

Old Mill.

Knypersley Bridge & Cottage.

The Grange.

BIDDULPH

Introduction

The parish of Biddulph nestles in a valley situated on the north western border of the county of Staffordshire. To the east of the Biddulph Brook, which flows north through Mossley Gap to join the river Dane at Congleton, the land rises to the moorland which forms the foothills of the south western edge of the Pennine chain. Towards the west the land forms a ridge which runs south west from the Mossley Gap rapidly climbing from 300 to 1,000 feet to create the prominent hill called Mow Cop, which overlooks the Cheshire Plain and onwards to the Welsh Hills.

Both the east and west ridges, which define the boundaries of the valley and the parish, are mainly formed of Millstone Grits, coarse sandstones that underlie the coal measures. Thus the whole of the Biddulph valley is composed of carboniferous rocks sometimes overlain by glacial sand and clay. It is these sandstones, clays, sand and coal seams that played such a significant role in the later economic development of the area.

In the sixteenth century the Biddulph Valley was heavily wooded and the land which had been cleared of trees (eg. The Fall) was poorly drained and the soil infertile, as is general on the cold coal measure strata. Even up to the beginning of the nineteenth century it was still a very isolated area with very little communication with the outside world. From the Norman conquest up to the beginning of the nineteenth century, almost the whole of the area was in the hands of three families: the Biddulphs, the Knypersley/Bowyer/Gresleys and the Verdon/Boughey/Mainwarings.

In 1810 the Knypersley Estate was bought by James Bateman of Salford for his son John, whose son James created the famous and recently restored Grange Garden, reopened by the National Trust in 1991. It was the Bateman family and their successor Robert Heath who were mainly responsible for the development of the valley throughout the period of the Industrial Revolution, opening the area to the outside world. Ten years before John Bateman came to live at Knypersley in 1811, the population of Biddulph was 1,180. In 1851, it had risen to 2,263 and by 1871, fourteen years after Robert Heath began to develop coal mining and iron making in the area, the population had increased to 4,769.

John Bateman was one of the people responsible for 'persuading' the North Staffordshire Railway into constructing the Biddulph Valley Line. Although the required parliamentary bill was passed in 1854, construction did not begin until 1858 and the first mineral traffic was not carried until 1860. This enabled Robert Heath to build the Biddulph Valley Coal and Ironworks and, in turn, this required a larger workforce and more houses in which to live. It was during this period that many of the houses and shops were built in the town now called Biddulph. In those days the area was named Bradley Green, the original site of Biddulph being the area in which the church, Grange House and ruins of Biddulph Old Hall stand.

By the mid 1870s Robert Heath had bought the Knypersley and Grange Estates from the Bateman family and the Greenway Bank Estate from the executors of Hugh Henshall Williamson. Robert Heath (snr) and then his eldest son lived at the Grange until 1921 when he offered the house and gardens as a gift to the North Staffordshire Cripples Aid Society for use as a hospital. Through lack of funds the society reluctantly declined the offer. In 1923 the Staffordshire Orthopaedic Hospital was created to take advantage of Robert Heath's generosity and during the next two years hospital wards were built in the garden. Unable to sustain its financial upkeep, it was sold to Lancashire County Council in 1926 for use as a children's orthopaedic hospital and school. In 1988 the garden created by James Bateman was acquired by the National Trust and when opened to the public in 1991, the hospital itself was closed after almost seventy years.

From 1860 onwards the main source of employment was Robert Heath's Biddulph Valley Coal and Ironworks. This remained so until 1928 when the business went into liquidation and iron production ceased. The colliery and forges were acquired by James Cadman, the coal mine continuing to produce coal until it was closed in 1982. The forges were taken over by Cowlishaw Walker, also owned by James Cadman, to manufacture mining machinery. When the coal industry was nationalised in 1947, Cowlishaw Walker remained as a private company manufacturing mining machinery until it closed in 1978.

While their men folk were toiling in the coalmines and after 1860 at the ironworks, the women found employment in the local textile mills. In the first half of the nineteenth century, cotton spinning was carried in the northern part of the parish. By 1850 cotton had been replaced by silk only to return once again to cotton about 1870, in the form of fustian cutting, which continued up to the 1930s. Women thus employed made a significant contribution to the family income, especially during short time working when the men were only able to work two or three days a week at the colliery or ironworks.

The only remaining large employer of labour in textiles in Biddulph today is Selectus Ltd, who employ 250 people. The Swiss firm had already been in existence 110 years when it established a mill in Biddulph in 1935 to make ribbons. Today it is known throughout the UK as the only manufacturer of Velcro fasteners in the country. Since the demise of coal mining and mining machinery manufacture in Biddulph, the area has mainly developed into a residential commuter area for the Pottery towns to the south and, to a lesser extent, northwards to Congleton and Manchester.

The photographs in this book have been collected over the past two years from people whose families have spent their lives in Biddulph. The book has been compiled to help preserve the ever dwindling photographic record of Biddulph people and the way they have lived, worked and played during the past one hundred years.

One

Biddulph:
The Countryside

Grange Road leading towards the Talbot Inn was part of the original road turnpiked in 1770 between Tunstall and Bosley. Until 1820 this was the only major road between Biddulph and Congleton. The road entering from the left is Fold Lane, the name a legacy of the ancient Grange Farm which, up to the early sixteenth century, was used for the benefit of the monks at Hulton Abbey, who grazed their sheep on the moorland above.

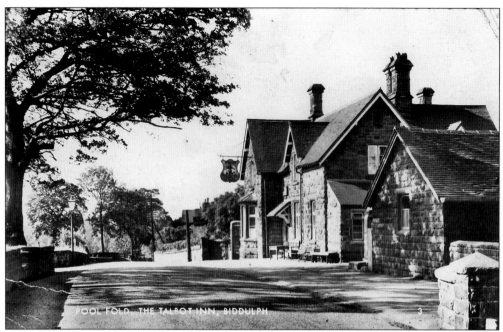

The Talbot Inn, Poolfold, Biddulph, *c.* 1950. An inn has stood on this site since at least 1775. It was often frequented by the Reverend Johnathan Wilson who came to Biddulph in that year and recorded his visits to the hostelry in his diary. It was later owned by the Stanier family who rebuilt the inn in 1868 and sold it in 1920 to Mr Joe Barker.

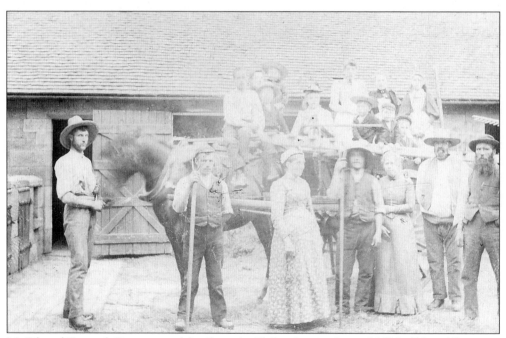

Mr Edward Turnock Bateman and family at the Talbot Inn in the mid 1890s. Edward Bateman (no relation of the Grange Bateman's) was both innkeeper and farmer.

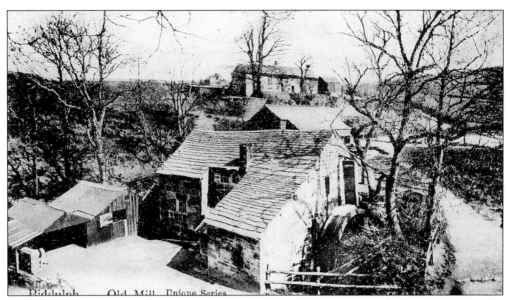

Biddulph Old Mill and Mill Cottage, before 1905.

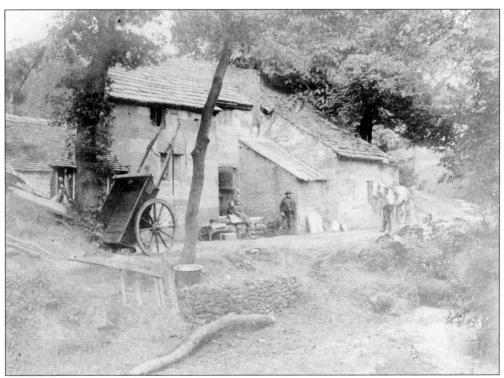

Biddulph Corn Mill, *c.* 1896. It is highly likely the mill predated the building of Biddulph Hall in the mid to late sixteenth century. The mill was still grinding corn using water power in 1912 but it had most probably ceased doing so by 1920. The last miller was Thomas Walley. (see page 12) The derelict mill was finally demolished in the late 1940s.

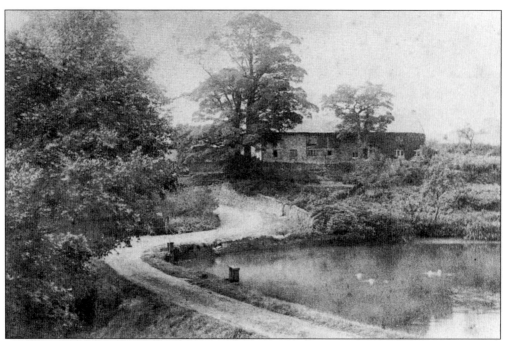

Biddulph Mill Pool and Mill Cottage, c.1896, the home of Thomas Walley. It was later to become the home of Tom Billinge, a well known local character. After lying empty for some years it was rebuilt by Mr Jack Charlton who dredged and restored the old mill pond which over the years had silted up. While carrying out this operation cannon balls fired at the nearby Biddulph Hall by Cromwell's soldiers during the Civil War were discovered.

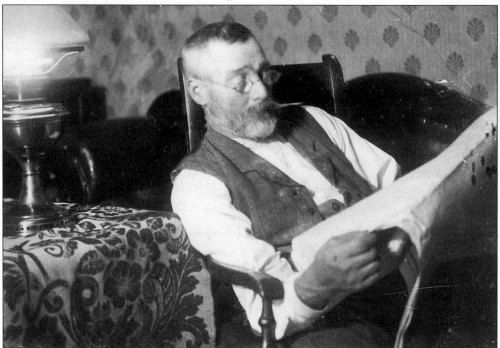

Mr Thomas Walley, sitting in the parlour of his home at Mill Cottage.

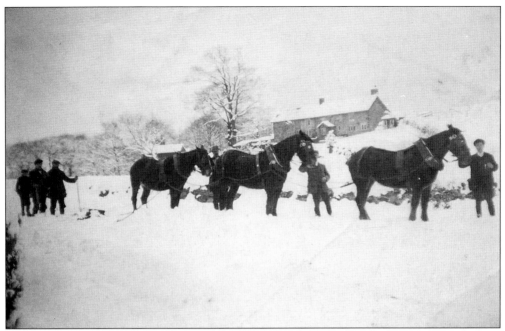

A winter scene at Biddulph Mill Cottage in the early part of the twentieth century.

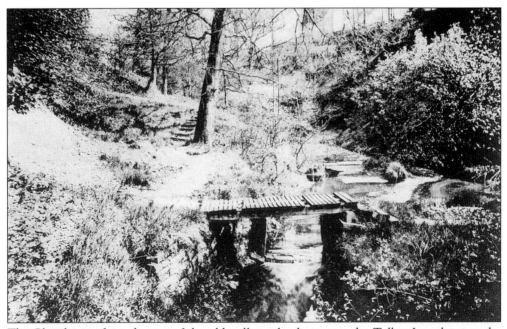

The Clough runs from the site of the old mill pond, adjacent to the Talbot Inn, down to the valley bottom where Lee Forge once stood. The steep sided valley was cut down to the bedrocks through the overlying glacial sand and boulder clay by the stream that was used to drive the water wheels at both Biddulph Mill and Lee Forge.

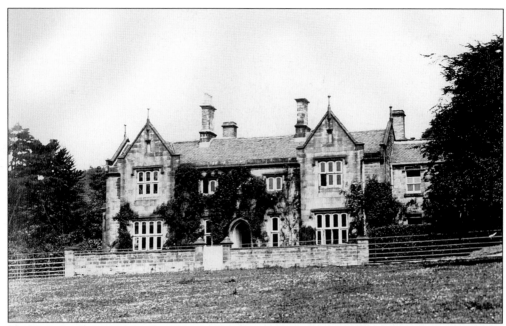

Elmhurst, built, *c.*1840 for the Reverend William Henry Holt, (Vicar of Biddulph 1831-1873) who was James Bateman's uncle. William vacated the old Grange House (at times referred to as the Vicarage) when James moved from his father's home at Knypersley Hall to live there with his wife and two children.

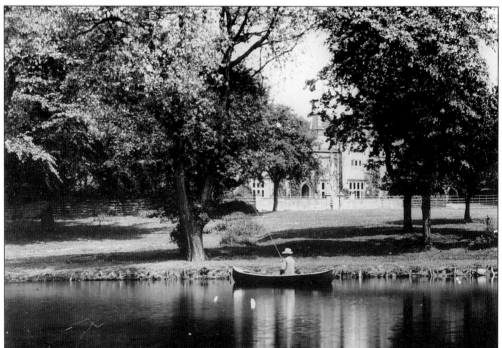

Elmhurst Mill pool served the silk mill owned by the Revd W.H. Holt and occupied in 1840 by Samuel Hawthorn. The mill was totally destroyed in 1852 and the occupier's son, Edward Harthen, was arrested and accused of robbing and setting it on fire.

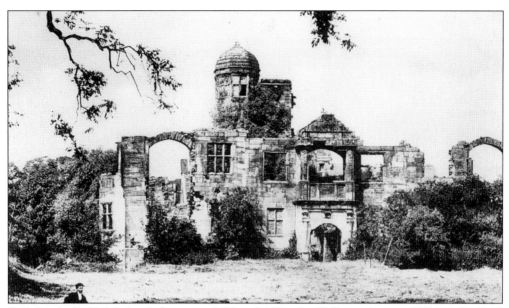

Built by the Biddulph family between 1558 and 1580, the Hall was destroyed during the Civil War in 1644, following a three month siege by Parliamentary troops. A house was subsequently built on the north side of the ruin using materials salvaged from the Hall. In 1779 it was occupied by Richard Myatt. During the 1960s it was used as a Buddhist retreat, since when it has been a private residence.

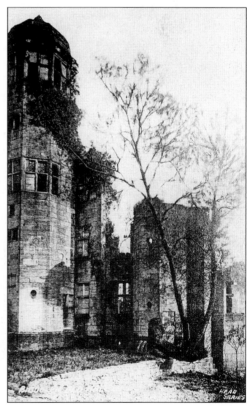

The pepper pot tower in the north wall of Biddulph Old Hall.

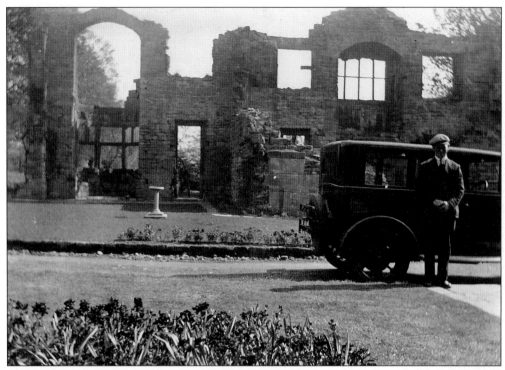

The garden within the ruined walls of Biddulph Old Hall.

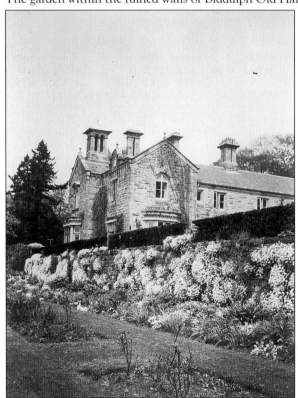

The Moor House. The Stonier/Stanier family lived in the area of the Hurst from as early as 1560. William Stonier lived in a house on the site in 1840. By 1843 Francis Stanier, a member of the Newcastle-under-Lyme branch of the family, had acquired and rebuilt the house, where they lived up to the 1870s. It was then leased to the Twyford and Leese families, being bought by the latter in 1920.

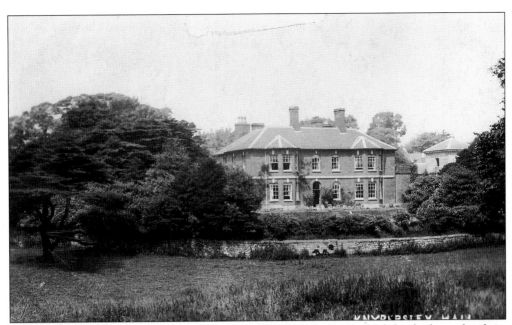

Knypersley Hall, site of the Knypersley/Bowyer/Gresley home was rebuilt by the latter family in the late eighteenth century. The Hall and estate were bought by John Bateman in 1810 and the third floor of the house was removed and its size reduced after his death in 1858.

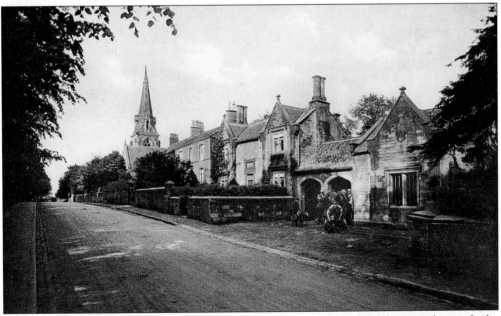

St John's Church and Knypersley Smithy, c.1920. The church and smithy, together with the vicarage (Fairhaven) and school, were built by John Bateman of Knypersley Hall between 1848 and 1851. A smithy on the same site occupied by William Ryder and owned by John Bateman is recorded in the 1840 Tithe Schedule. The smithy was probably established sometime after 1779 and in 1801 was occupied by John Ryder. William Taylor was the blacksmith in 1947 when it ceased to be a smithy, his family having been blacksmiths there for the last one hundred years. Sadly both the stone house and smithy were demolished in 1967.

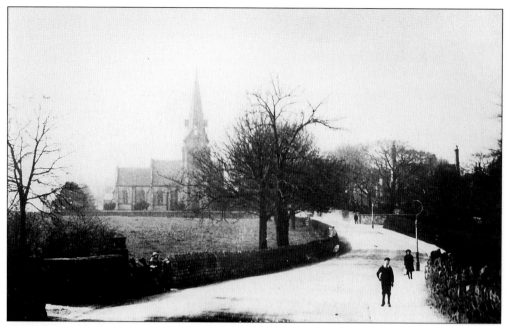

Tunstall Road looking south towards St John's Church, Knypersley, *c.*1916.

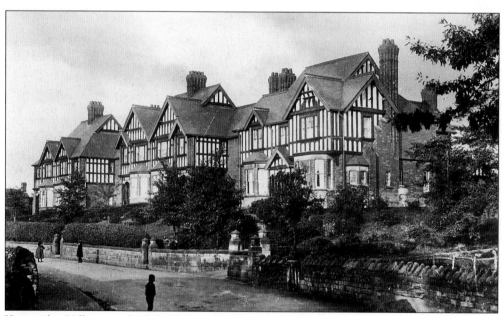

Knypersley Villas were built by Robert Heath sometime before 1912 to house senior officials from his ironworks and colliery. The large detached house later became the vicarage for Knypersley Church.

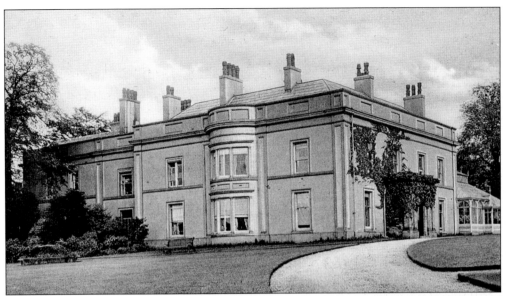

Greenway Bank Estate was purchased in 1778 by Hugh Henshall who completed the Trent and Mersey Canal following the death of James Brindley. In 1781-83 the Serpentine Reservoir was constructed close to where he built his mansion. Hugh Henshall left the estate to his nephew Hugh Henshall Williamson, who went to live there in 1823. By 1828 he had rebuilt the house and continued to live there up to his death in 1867. The estate was bought by Robert Heath in 1871 and members of that family lived there until 1971. The 121 acre estate was bought by Staffordshire Council in 1973. The house was sadly demolished, made unsafe through vandalism, and the estate turned into a country park.

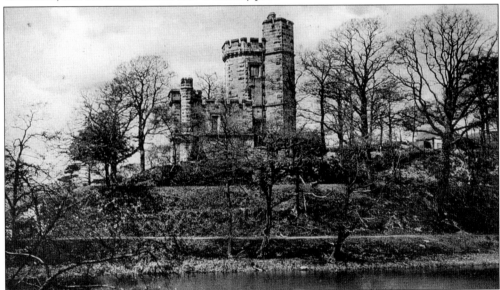

The Warder's Tower, Knypersley Park, (now Greenway Bank Country Park) was built by John Bateman in 1828, the year after the completion of the New Reservoir for the Trent and Mersey Canal Company. The deer park at Knypersley mentioned by Sir Simon Degges (1612-1704) as containing deer was disparked in 1795, but was restocked in 1859 with eighty fallow deer by James Bateman.

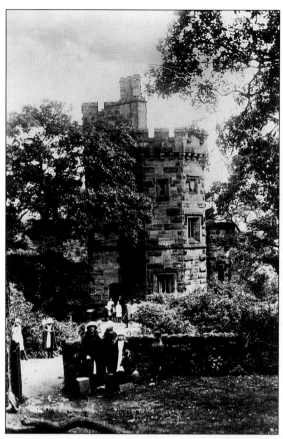

Knypersley Warders Tower, *c.* 1930

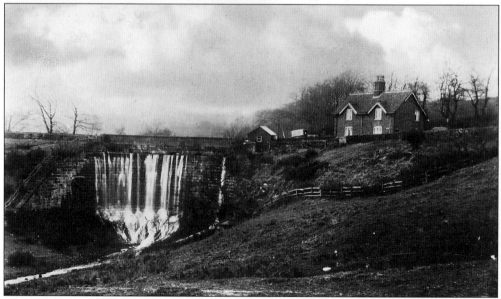

The overflow in the dam of Knypersley New Reservoir. The old mill submerged by the construction was replaced by the one which can now be seen below the falls. The bridge above the falls is the original stone bridge, replaced in the mid 1930s.

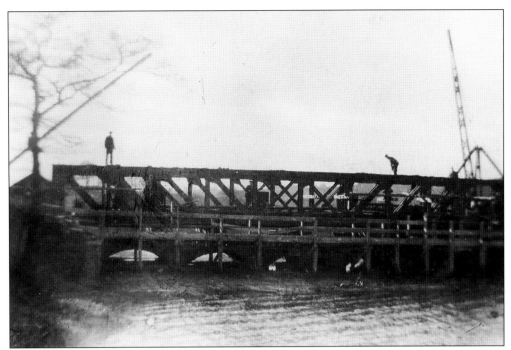

Knypersley Reservoir overflow. The old stone arch bridge carrying Judgefield Lane over the reservoir outflow at the eastern end of the dam was replaced in the mid 1930s by a steel girder bridge.

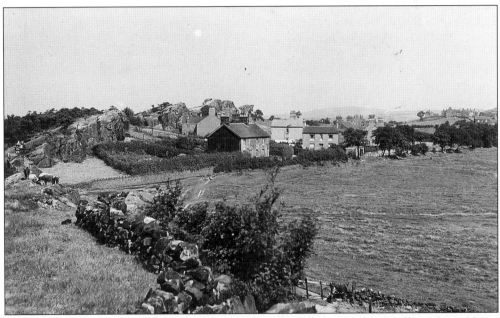

Rock End, Biddulph. Rock End stands at the top of Park Lane, known locally as Gutter Lane (Guthram's Lane?). Looking north to the Cloud, Wickenstone Rocks on the left are outcrops of Chatsworth Grit and the houses on the extreme right are the start of the village of Biddulph Moor.

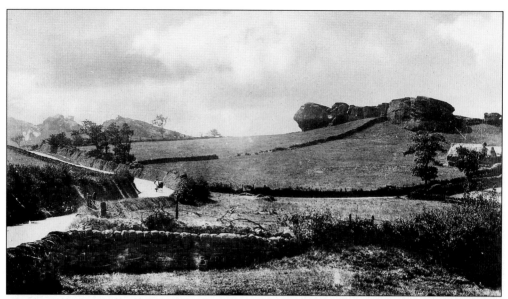

Wickenstone Rocks, Biddulph Moor, are the rock outcrops that were said to have given James Bateman the inspiration for the grandiose rockwork that he created in his garden at the Grange.

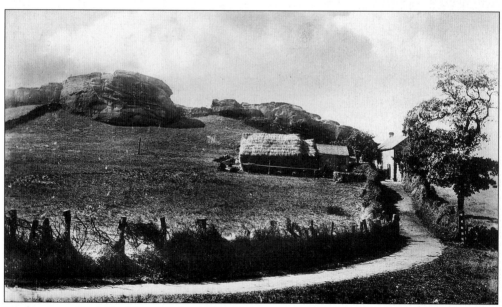

Wickenstone Rocks looking west from New Street.

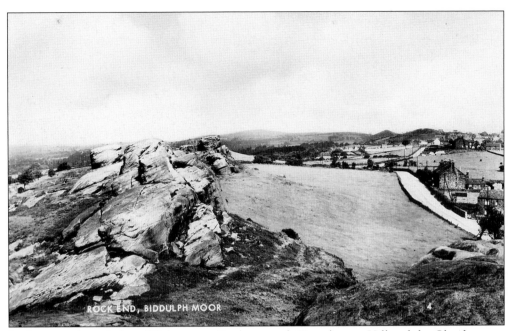

Looking northwards from Wickenstone Rocks towards Troughstone Hill and the Cloud.

Coppice Wood, today but a shadow of its former self, lies on the eastern side of the Biddulph Valley below the Wickenstone Rocks.

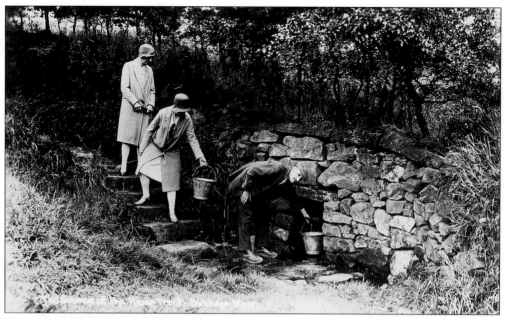

Trent Head Well, Biddulph Moor - the source of the River Trent, whose waters flow into the North Sea. A short distance away is the source of the Biddulph Brook, the water of which eventually finds its way into the Irish Sea.

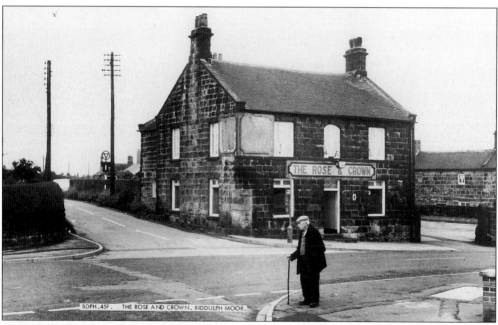

Mr William Finney standing opposite the Rose and Crown at the crossroads in the centre of the village of Biddulph Moor. Bill was one of the original Moor folk who spoke the local dialect which was like a foreign language to anyone who came from outside the Biddulph Moor area.

24

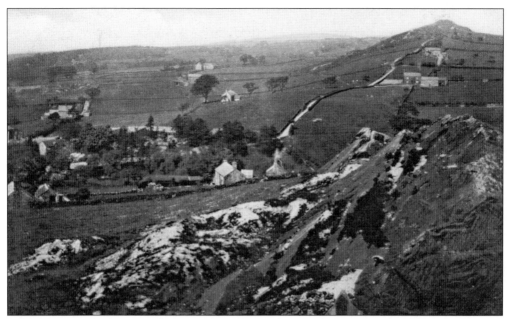

Biddulph Moor looking north from Job Will's Rock towards Troughstone Hill (1,017 ft) and the Cloud (1,100 ft). This ridge is formed by the Chatsworth Grit which dips west beneath the Biddulph Valley. Spring House, built by the Holt brothers, stands centre left.

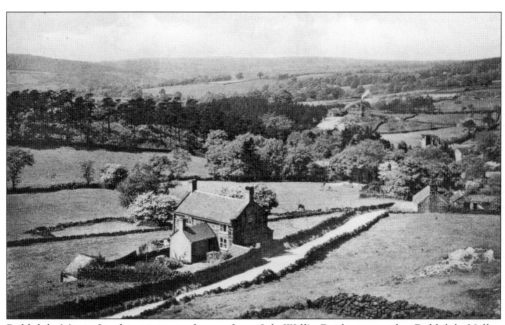

Biddulph Moor. In this view northwest from Job Will's Rock across the Biddulph Valley towards Congleton Edge, Spring House stands on the extreme right in the hollow. The sand quarry in the Rough Rock, exploited by the Holt Brothers, lies to the northwest of the house.

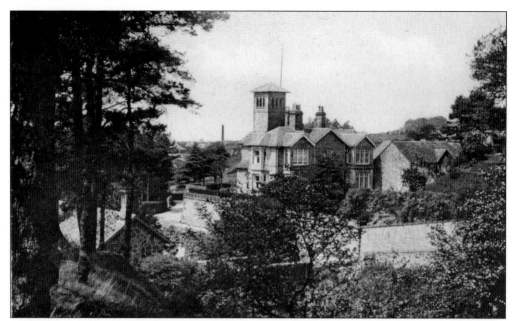

Spring House, built in 1872 for William Holt, son of William Henry Holt, (Vicar of Biddulph 1831-1873), who was James Bateman's uncle. In the directories from 1876 to 1912, William Holt and his brother Edward were described as potters' sand merchants, extracting sand and sandstone from the quarry adjacent to their home.

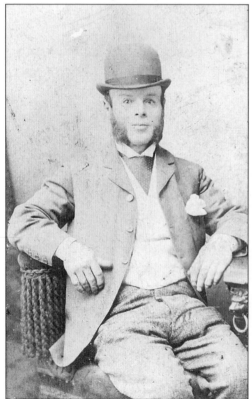

Henry Holt, son of the Reverend William Henry Holt, who lived at Spring House (also known as Hurst Towers) with his elder brothers William and Edward.

Gorse Bank. This wooded area once stood where the Holts, and later Hinkleys, quarried and crushed the rough rock sandstone. The beer house named the Flying Fox was demolished as the quarry working extended through the area.

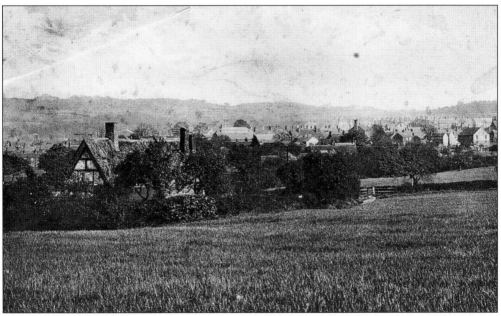

View eastwards over Biddulph town towards Biddulph Moor and Rock End. The White House in the foreground, a cruck-framed, thatched-roof house is the oldest inhabited dwelling in the area, dating back almost certainly to the sixteenth century. Other houses, namely Gillow Fold and Beacon House, still possessing cruck frames in their existing structure, have been rebuilt - the former by William Stonier in 1676.

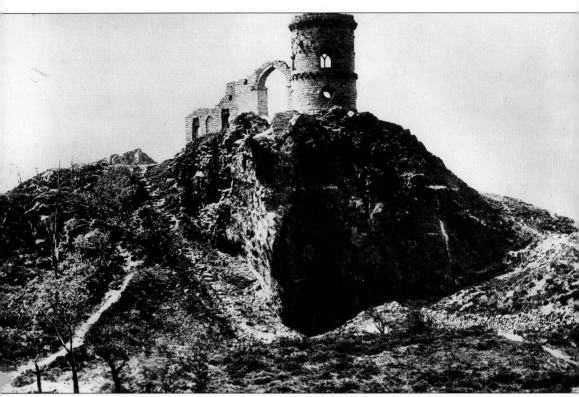

Mow Cop Castle, built as a folly, c.1760 by the Wilbraham family of Cheshire, stands at the southern end of the western ridge of the Biddulph Valley. Situated at one thousand feet it makes a superb viewing point from which to see the whole of the Biddulph area.

Two

Biddulph:
The Village

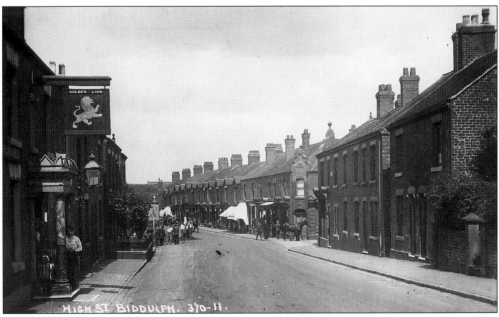

The bottom of Tunstall Road looking into Biddulph High Street in the early 1930s. The Golden Lion ceased to be a public house around 1960 when the Top o'the Trent was built on the miners' estate developed by the National Coal Board.

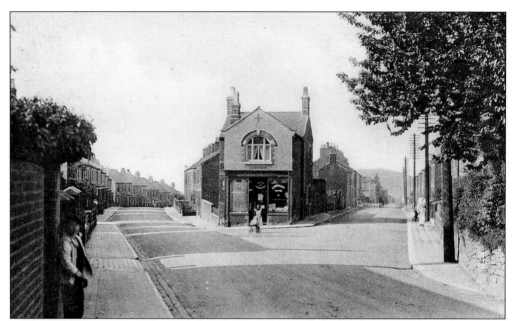

Tunstall Road and John Street, *c.*1919, the approach to the village of Bradley Green from the south. When this card was posted in 1919 the village was still known as Bradley Green and it was not until the early 1930s that it started to be called Biddulph, after the name of the parish. In 1861 a terrace of houses was built on the right hand side of Tunstall Road and named after Roland Bateman. At the same time the development of John Street was started on land sold by his father, James, who imposed what must have been the first planning conditions in the Biddulph area, by laying down the building specification for the houses, width of road and pavements, size of gardens and distance between properties. The shop at No.77 John Street West, is that of George Walley, greengrocer and confectioner.

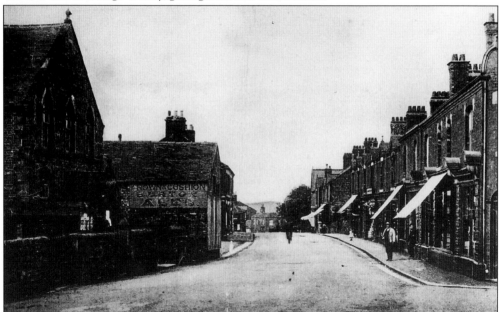

High Street, Bradley Green, at the beginning of the twentieth century.

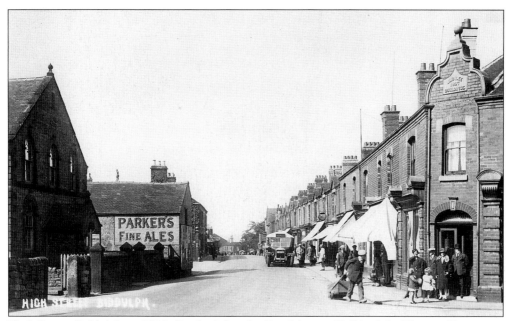

High Street, Biddulph, *c.* 1930. On the left is the Free Mission Hall built by Thomas Sherratt in 1886, known locally as Bella's Mission after his wife. In 1900 it became part of the Wesleyan Methodist circuit and was finally closed in 1967. On the right, at the junction of Well Street, are the Jubilee Buildings erected in 1887. The people are standing in the doorway of John Copeland, cabinet maker and furniture shop.

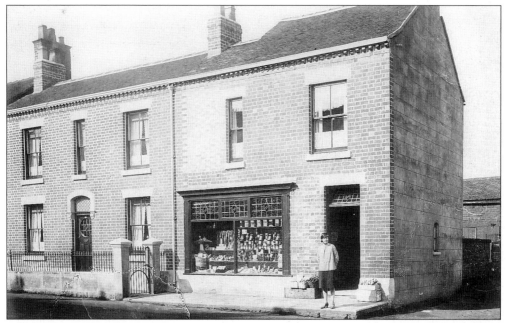

John Weston, greengrocer, No.2 Tunstall Road, *c.*1932, on the site of what is now The Cottage Bakery and Coffee Shop. To the right stands Crown Bank Garage.

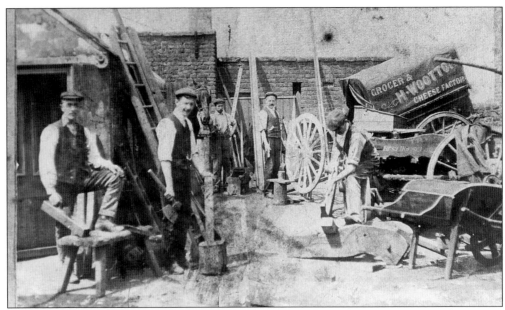

Isaac Holland's work yard in 1912. George Morris and Jack Weatherby stand at the rear and George Weston, Jacob Holland and Isaac Holland in the foreground. The covered cart belonging to Henry Wooton can also be seen standing in front of his grocers in the High Street around 1920 on page 35. On the right stands Wesley Hall Chapel.

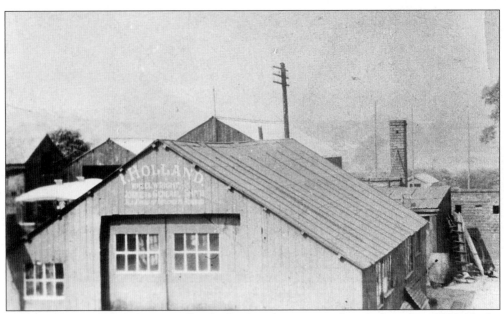

The workshop and yard of Isaac Holland, wheelwright, joiner and general smith in 1930. To the left stands Crown Bank Garage, the depot of Biddulph and District Motors Ltd. In 1936 the company sold out to the North Western Bus Company who occupied the area until 1961. Today Biddulph Library stands on the site.

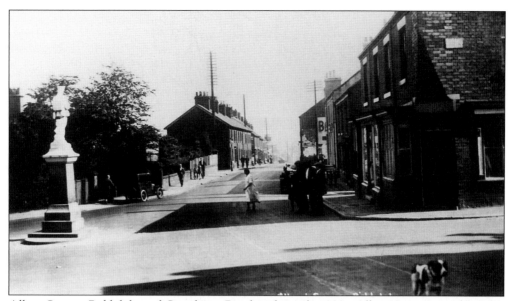

Albert Square, Biddulph, and Congleton Road in the early 1930s. Albert Street is on the right. The monument to the Biddulph men who were killed in the First World War was erected in 1922 and sculpted by Jonah Cottrell, monumental mason, whose stone yard was beyond the houses on the left side of Congleton Road.

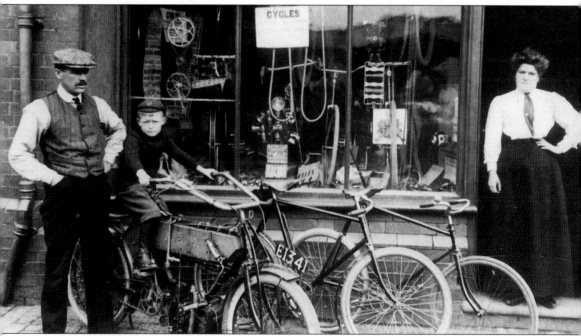

Ernest Wells' first shop at 31 Congleton Road, c.1911, (situated half way down the row of houses on the left hand side of the previous picture). In 1914 he began a motor bus service based at No.4 High Street, which was to be developed by his son Henry (sitting on the motorcycle) into the largest and most successful of the Biddulph bus companies. The company, together with its depot in Congleton Road and nineteen buses, was bought in 1953 by the Potteries Motor Traction Company.

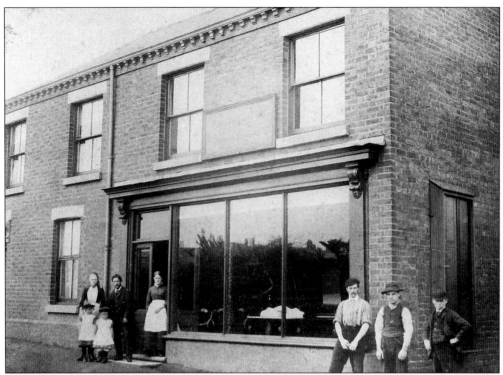

Before moving to the Jubilee Buildings (see page 31) John Copeland and his father George carried out their business as cabinet makers and undertakers at 49 Bridge Street (now renamed Congleton Road) from as early as 1884. Here, John, his wife and two small daughters are standing in the doorway of their shop around 1900.

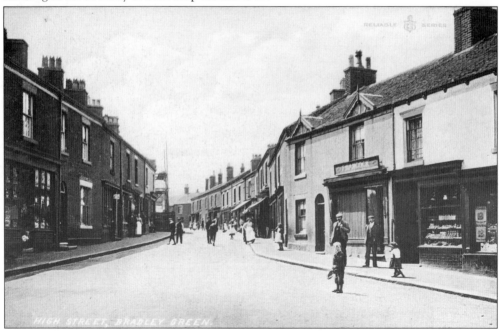

Lower High Street, Bradley Green, south of Albert Square prior to 1916.

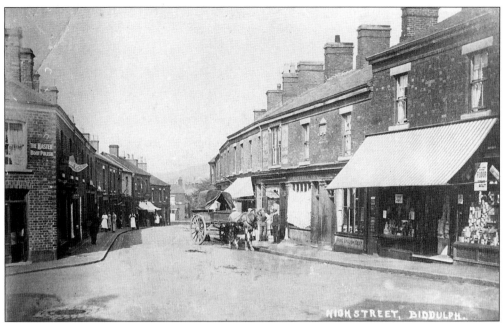

Looking towards Albert Square in the mid 1920s. The horse and cart (see page 32) are in front of Henry Wooton's green grocery shop at No.31 High Street. Closer are Mr George Cottrill's boot and shoe repairs, Whitehurst butchers and at No.37, the 'Modern Stores' of William Cottrell, grocer and provision dealer. In the left hand corner is the shop of Edward Linney, boot and shoe maker.

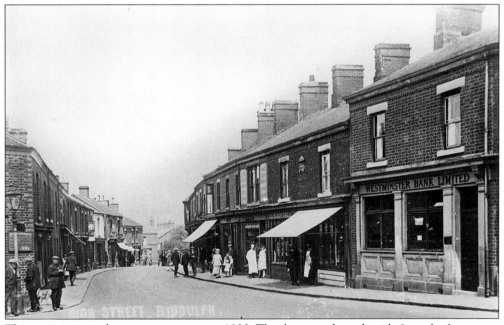

The same scene as the previous picture, c. 1930. The shops on the right side from the far canopy are No.27, Mrs John Booth, draper; No.29, Harold Jones, tailor; No. 31, William Lunt, grocer, (Mr Lunt and his daughter stand in the doorway); No. 33, Cottrill's boot and shoe repairs; No.35, William Whitehurst and Son, butchers and No.37 the Westminster Bank.

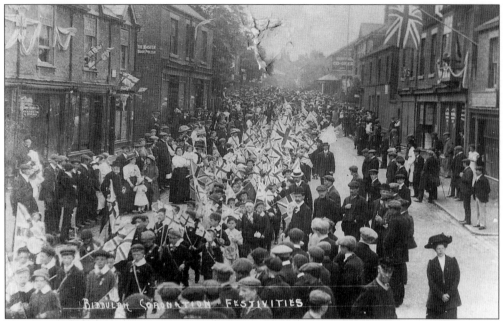

Biddulph celebrating the coronation of King George V and Queen Mary in 1910. In the distance on the right is the wrought iron canopy of the Congleton Co-operative Stores.

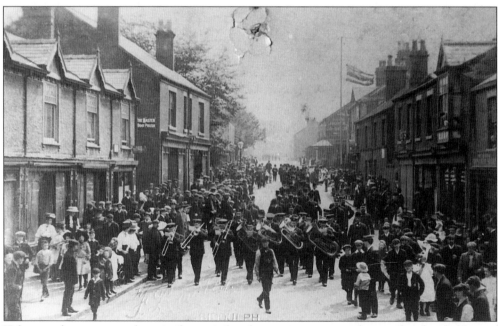

Taken at what appears to be a similar period as the previous picture, the parade is headed by one of the many bands that existed in Biddulph at that time. The occasion is not known but the flag at half mast suggests that the reason for the parade was the death of King Edward VII.

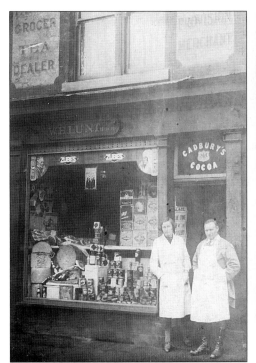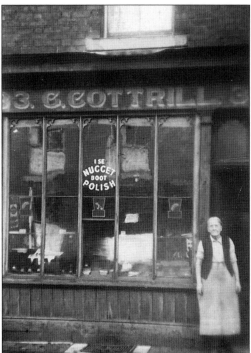

Left: Mr and Mrs Thomas Whitehurst standing in the doorway of their shop at No.31 High Street, shortly after acquiring it from William Lunt in 1932. Right: George Cottrill was established at No.33 High Street as a boot and shoe repairer by 1925. He was known locally as 'Clogger' Cottrill, making and selling clogs to the colliers and ironworkers who made up the greater part of the male population of Biddulph.

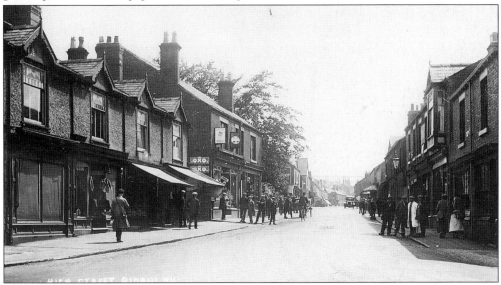

The High Street, looking south from Station Road, c. 1930. The shop with the Oxo advertisement on the wall is Bentley's confectionery and tobacconists which the family bought in 1924. The street lamp on the right stands at the front of James Weston, grocer, 42 High Street. In the distance a car stands in front of the Congleton Co-operative store.

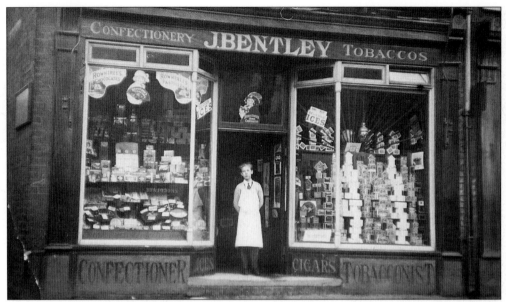

John Bentley (jnr) standing in the doorway of his father's shop, *c.* 1927.

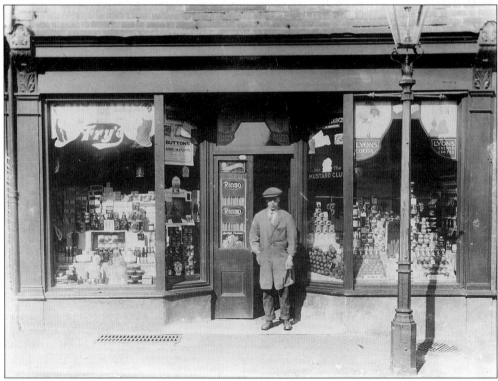

John Weston was a grocer at No.42 High Street from as early as 1928.

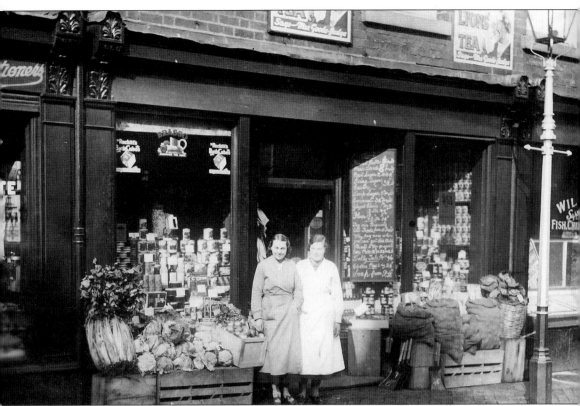

By 1932 John Weston had opened a second shop at 2 Tunstall Road, leaving his sister Doris (left) in charge of 42 High Street.

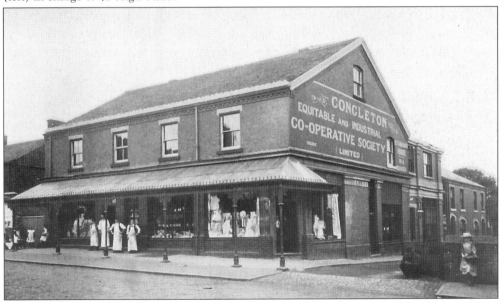

The Biddulph Branch of the Congleton Co-operative Society in 1897. The shop included grocery, drapery, boot, clothing, furnishing and butchery departments as well as the branch office and two cottages.

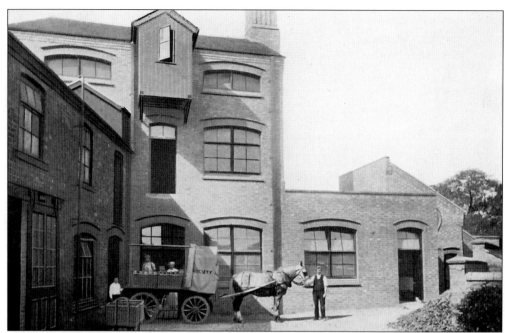

The bakehouse of the Biddulph Branch of the Congleton Co-operative Society in 1908. The output of bread at this time was 4,000 4 lb loaves a week.

Bought by the Biddulph Urban District Council in 1895 from the Knypersley Lodge of the Independent Order of Oddfellows, the Public Hall was in use up to the completion of the new Town Hall in 1966.

Three
The Grange

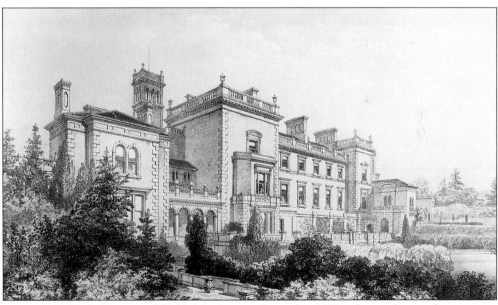

An architectural drawing of Biddulph Grange from the 1871 sale catalogue, the mansion created by James Bateman during the late 1840-1850s on the site of the ancient Grange Farm.

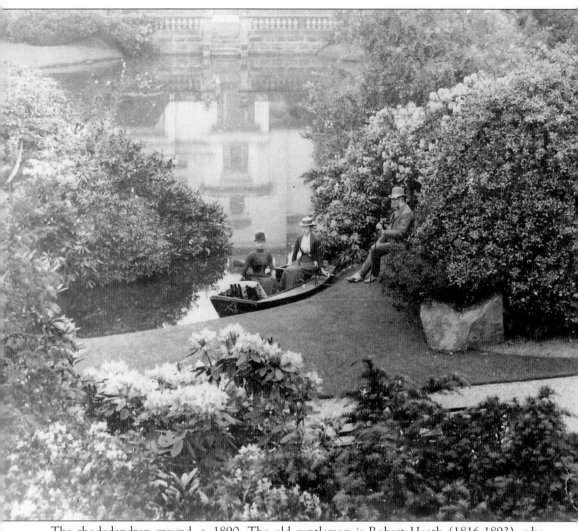

The rhododendron ground, *c.* 1890. The old gentleman is Robert Heath (1816-1893), who created a vast industrial coal and iron empire in North Staffordshire. He purchased the Grange Estate from James Bateman in 1872 and went to live there two years later.

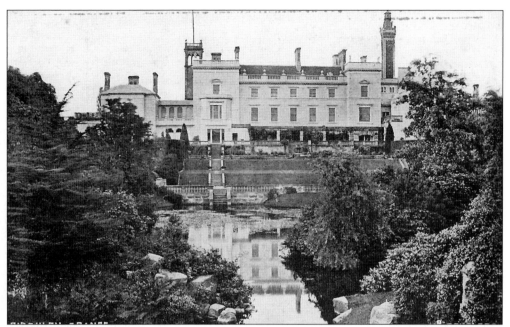

Biddulph Grange, *c.* 1890, prior to the fire.

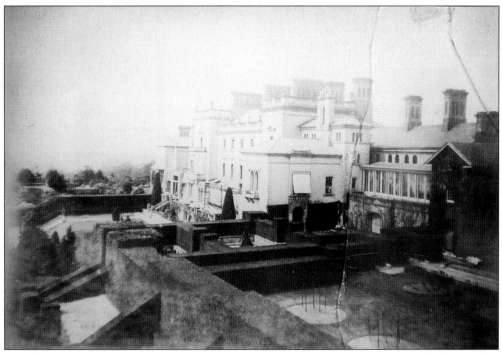

Biddulph Grange, *c.* 1895 at the commencement of building alterations for Robert Heath (jnr). It was after the completion of these alterations that the house was devastated by fire in January 1896.

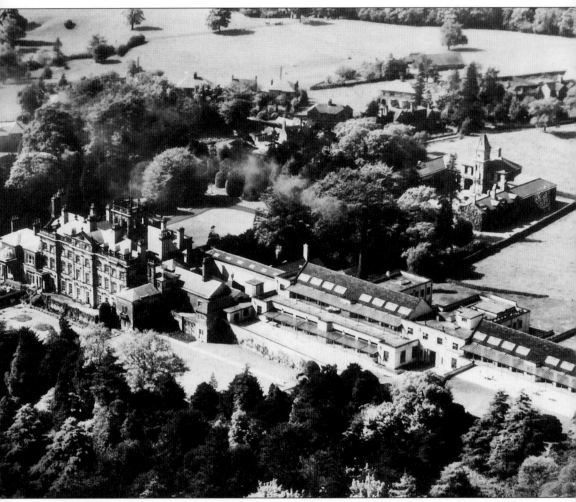

Biddulph Grange Hospital. Biddulph Grange on the left was rebuilt by Robert Heath following a fire in 1896 which destroyed much of James Bateman's original house. The new hospital on the right was completed in 1938. Above this stand the stables which became the hospital laundry.

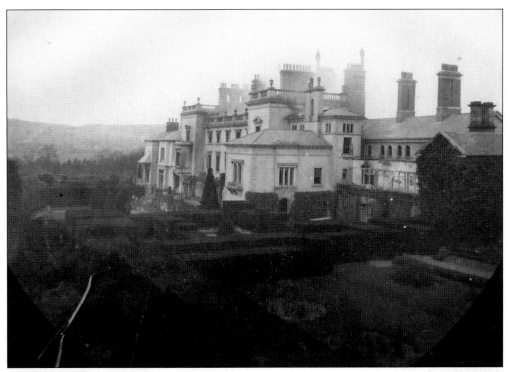

Above and below: Fire damage at the Grange.

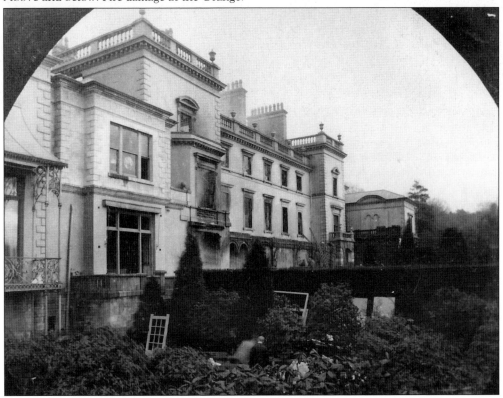

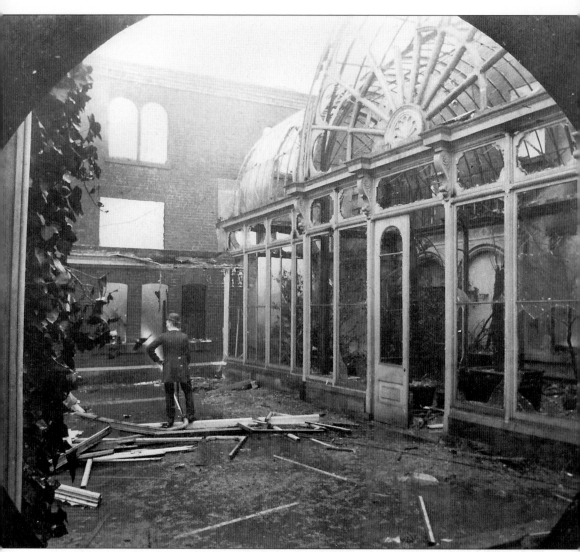

Fire damage to the conservatory at the rear of Grange House.

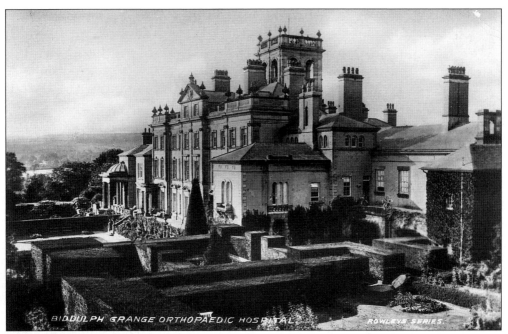

The Grange as it was rebuilt for Robert Heath (1851-1932) after the fire. In 1923 Robert made a gift of the house and garden to the Staffordshire Orthopaedic Hospital, who in turn sold it in 1926 to Lancashire County Council for the care and education of the crippled of East Lancashire. On the right in the foreground is the cherry orchard on which the first wooden wards were built in 1924.

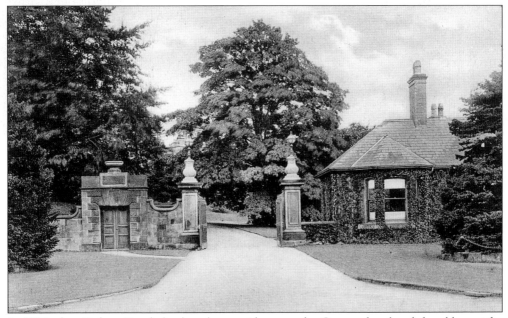

In 1874 when Robert Heath (snr) took up residence at the Grange, he closed the old turnpike road which ran along the side of the house and constructed the present Grange Road. At the same time he created a new entrance and lodge leading from Grange Road to the north side of the house.

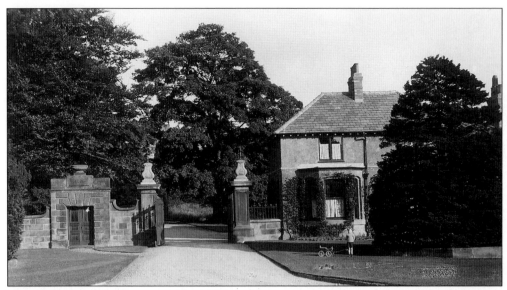

The lodge was rebuilt to provide additional accommodation after the Grange became a hospital.

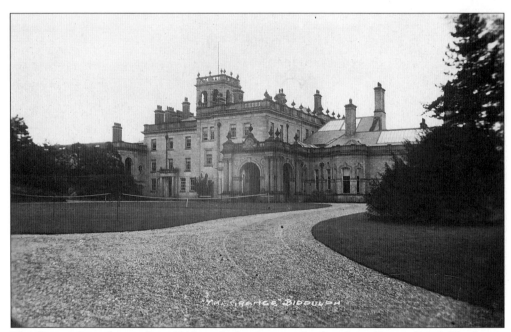

The Grange from the north, *c.* 1912, with the driveway leading from Grange Road. The house is as it was rebuilt by Robert Heath (jnr) in 1896.

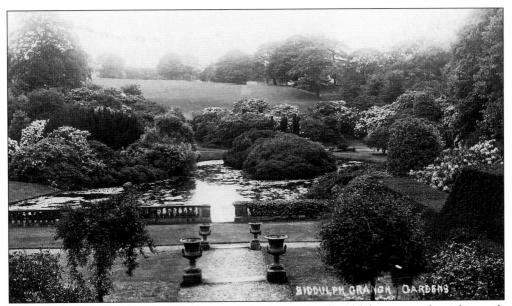

Biddulph Grange Garden, c.1930, the rhododendron ground and lake as seen from the south terrace of the house. The rhododendrons are normally at their best in late May and early June.

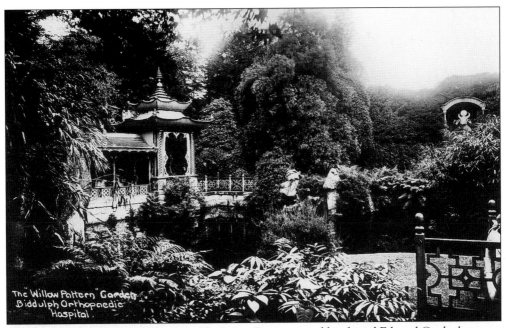

The Chinese Garden, c.1930, created by James Bateman and his friend Edward Cooke between 1855 and 1859, considered to be the finest example of its kind in the country. The temple, Joss House and bridge, designed by Cooke, have been restored by the National Trust who acquired the garden in 1988.

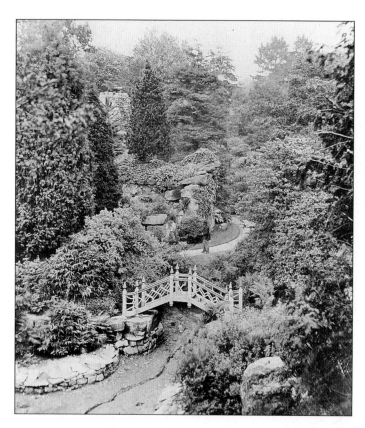

'China' at about the turn of the nineteenth century.

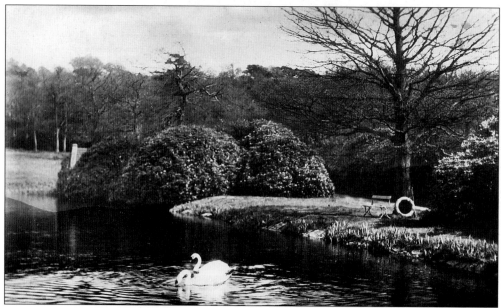

The Lake, now part of the Grange Country Park, was constructed by Robert Heath in 1903. Besides being a source of recreation it provided power to the estate workshop water turbine and water to hydrants in the house in case of a further outbreak of fire.

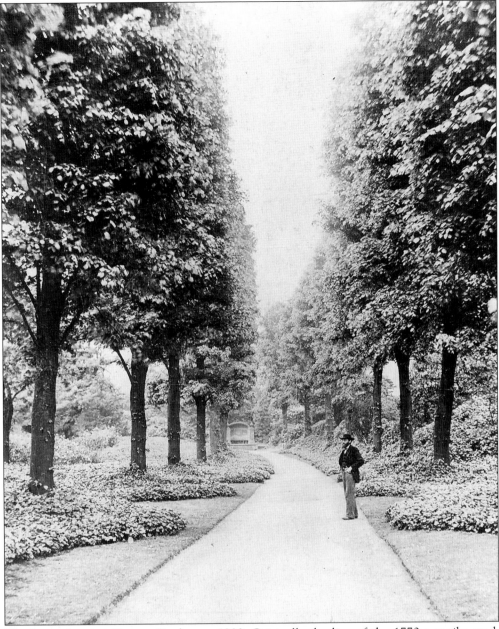

The Lime Avenue, Grange Garden, c. 1900. Originally the line of the 1770 turnpike road, James Bateman moved the road some thirty yards to the left in order to create the avenue of lime trees.

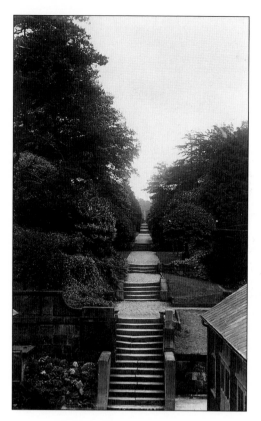

The Mile, or Obelisk Walk, passes through the Wellingtonia Avenue so named after the Giant Sequoia trees planted there by James Bateman and subsequently felled by Robert Heath. The effect of an obelisk was created by a path composed of white sand rising up the hillside beyond a huge stone vase. Work on the restoration of the avenue has been carried out for the National Trust during the 1995/1996 winter season and the first of the forty-four new Wellingtonia trees was planted on 28 March 1996.

Mr Mees, Robert Heath's gamekeeper, probably at his cottage on the edge of Sprink Wood, where Sprink Side Farm now stands.

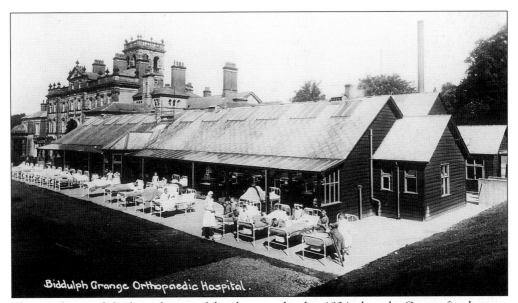

The wooden wards built on the site of the cherry orchard in 1924 when the Grange first became a hospital. Their use was prolonged by the Second World War until 1946, eight years after the new wards and operating theatre had been completed.

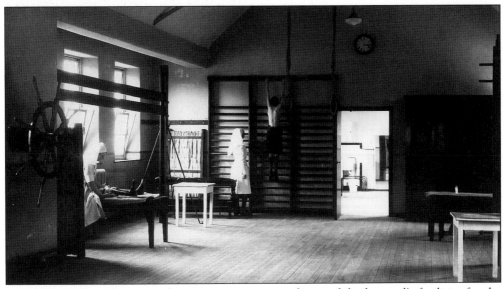

The gymnasium and massage department - an essential part of the hospital's facilities for the care of its young patients.

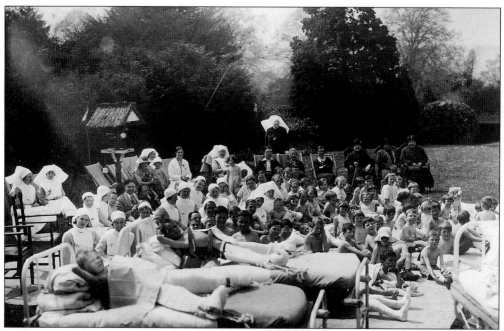

Patients and staff on the lawn at the front of the wooden hospital wards, *c.* 1936. Miss Rochell, the matron, is standing at the rear and three old ladies who lived in the almshouses built by the Batemans in 1859 are seated on the right.

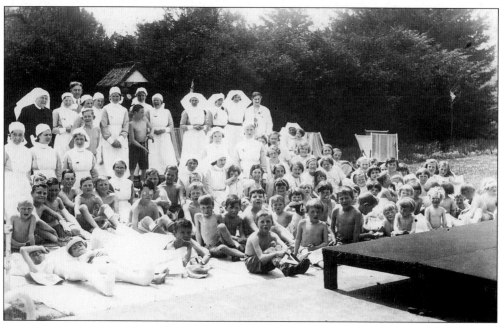

Young patients and staff waiting to be entertained, a stage having been built on the lawn in front of the wooden hospital wards.

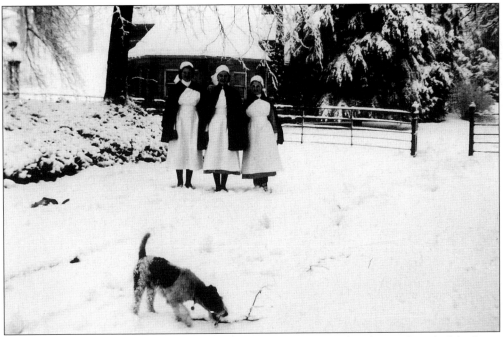

This is the only known photograph of the lodge which once stood at the south end of the Lime Avenue. On the left are the gates to the carriage drive which have since been restored by the National Trust and re-sited where the nurses stand. After being derelict for many years, the lodge was finally demolished in the early 1960s.

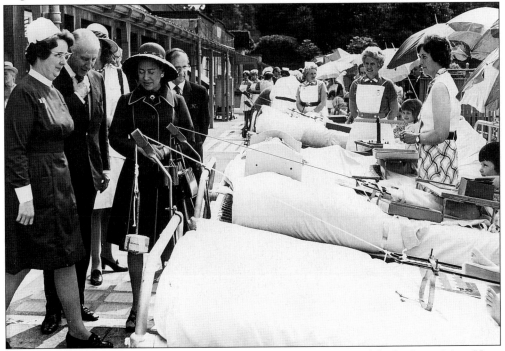

Princess Margaret meeting the young patients, who were being cared for by Sister Mary Hart, when she visited the Grange Hospital in July 1973.

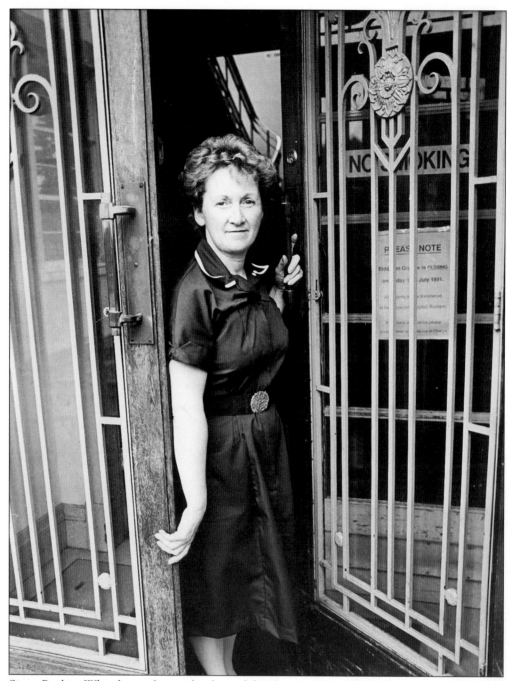

Sister Pauline Whitehurst closing the door of the Grange Hospital for the last time on 12 July 1991, shortly after the garden had been opened to the public by the National Trust.

Four
Transport and Industry

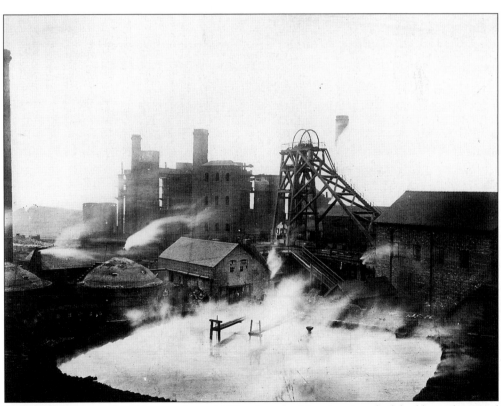

Biddulph Valley Coal and Ironworks, c. 1901, when the Magpie mine shaft had been deepened and renamed Victoria. The ironworks' blast furnaces stood on the left of the Victoria shaft winding heapstead and the railway wagons in the left foreground bear the initials of Robert Heath and Sons, its owners.

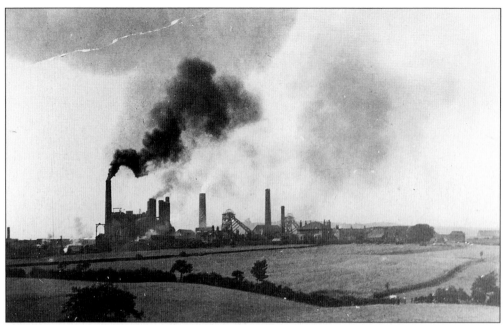

Biddulph Valley Ironworks, *c*. 1920 looking from the direction of Greenway Bank, the home of Robert William Heath, whose father lived at the Grange.

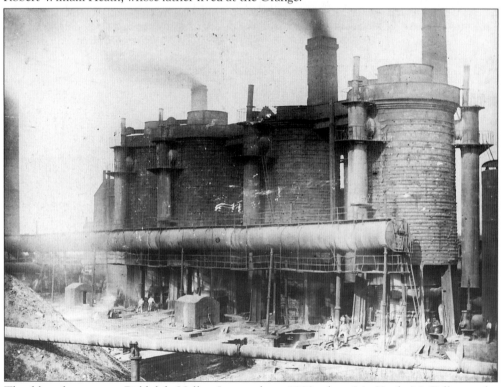

The blast furnaces at Biddulph Valley Ironworks, *c*.1920 when Mr Hugh McCall was the ironworks' manager. In 1919 Robert Heath amalgamated with Lowmoor Ironfounders of Bradford and in 1928 went into liquidation.

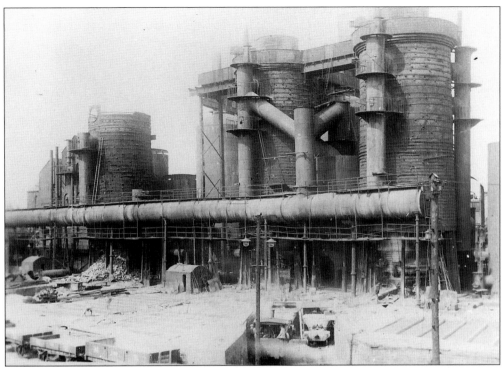

These two pictures show the reconstruction of the blast furnaces carried out probably some time after the amalgamation of Robert Heath and Lowmoor. They show the number of blast furnaces being reduced from four to three and No.2 furnace being completely rebuilt. The railway wagon in the forefront is one belonging to the North Staffordshire Railway Company.

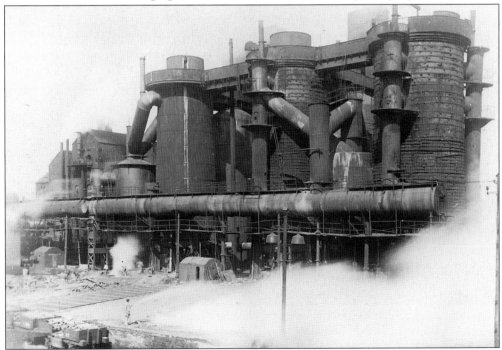

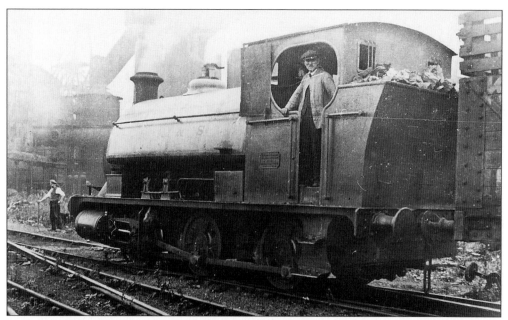

Locomotive No.15, built at the Biddulph Valley Ironworks in 1915, by Robert Heath.

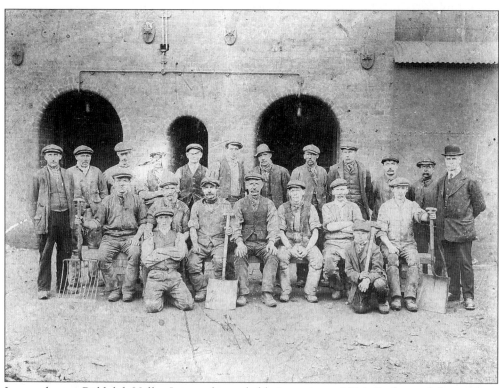

Ironworkers at Biddulph Valley Ironworks, probably just prior to 1914. Back row, left to right: -?-, -?-, -?-, G. Byatt, ? Dean, ? Chaddock, Sam Sherratt, -?-, Machin, -?-, -?-, -?-. Seated: -?-, -?-, Plant, -?-, Jack Shufflebotham, ? Lear, Jim Hazeldine.

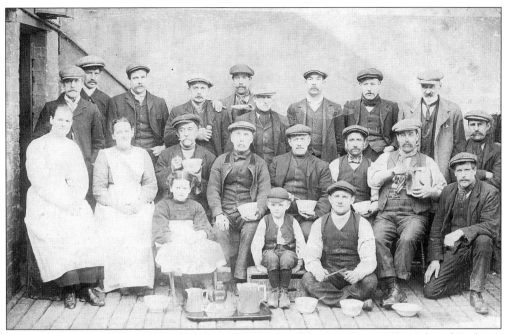

Ironworkers from Black Bull, Biddulph Valley Coal and Ironworks, *c.* 1921. Edward Bailey is sitting third from the left and Robert Stubbs stands fourth from the left.

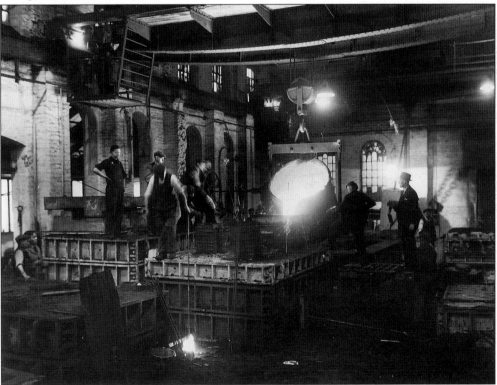

The casting shops of Cowlishaw Walker Engineering, *c.* 1952, situated in the Biddulph Valley Ironworks old foundry. The man wearing the trilby hat is the works manager, Mr Petrie.

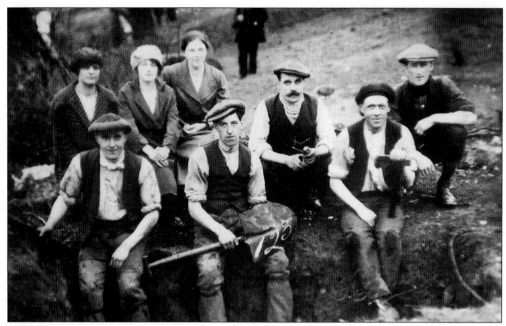

Miners out-cropping for coal during the 1926 General Strike.

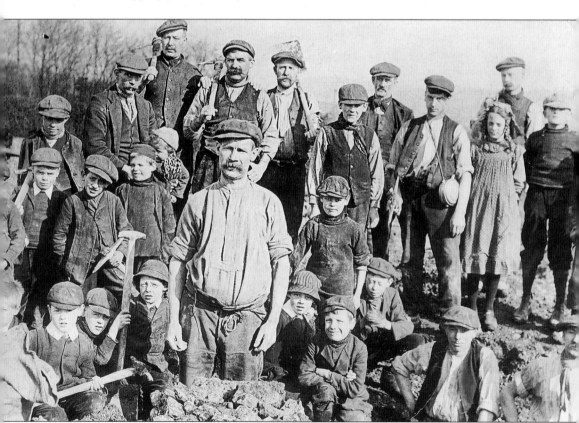

Coal out-cropping in the Biddulph Valley, probably during the 1912 coal strike.

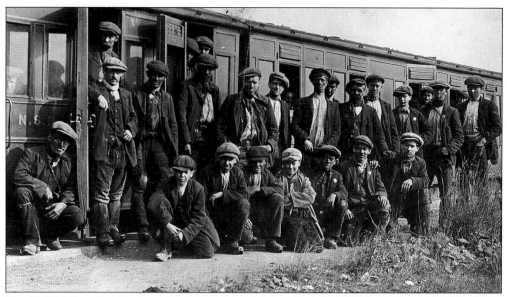

The Biddulph colliers' train, early 1920s. The train ran from Biddulph to Chatterley Whitfield Colliery from 1890. In 1919 it was extended to Mossley Halt to accommodate colliers living in Congleton. By 1926 competition from road transport caused the service to be withdrawn. Standing in the first doorway is Moses Booth and in the second, Moses Bradbury and William Pickford. On the back row are Jim Bass (kneeling), Abner Shufflebotham, Jim Brough, Jack Woodward, Jack Smith, Tom Pointon, Hugh Proctor, -?-, Richard Horton, William Cottrell, -?-, Frank Stanway and Cliff Embrey. Front kneeling: Harold Booth, -?-, Arthur Bracegirdle, -?-, Ronald Horton, Albert Fitzgerald, -?-.

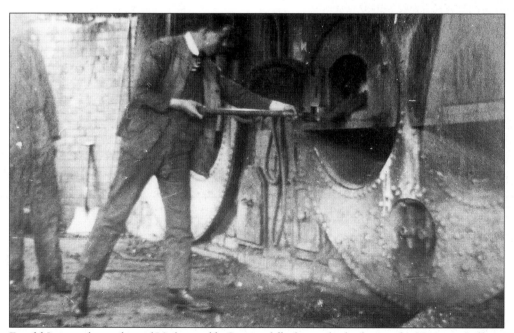

Ernald James, the author of *Unforgettable Countryfolk*, firing the boilers at the Victoria Colliery in the 1926 coal strike.

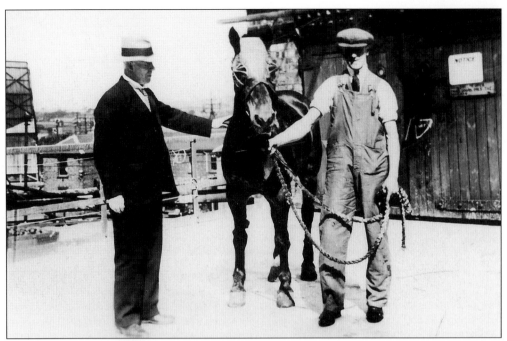

Mr Alf Copeland bringing out the last pony to work underground at Victoria Colliery, *c*.1930.

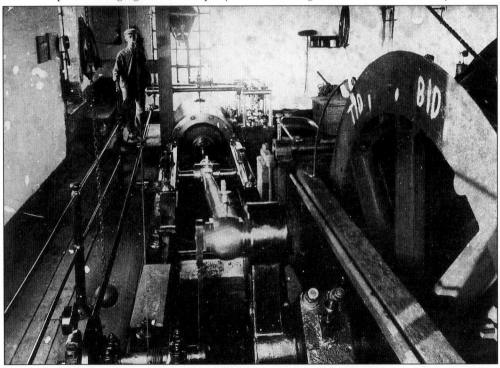

Brown Lees Colliery was acquired by Robert Heath from the Williamson family in 1887. Shortly afterwards Robert deepened one of the shafts. This winding engine would have wound from both shafts prior to the deepening and after, continued to wind from the shallow upcaste shaft. Brown Lees Colliery ceased to produce coal in 1927.

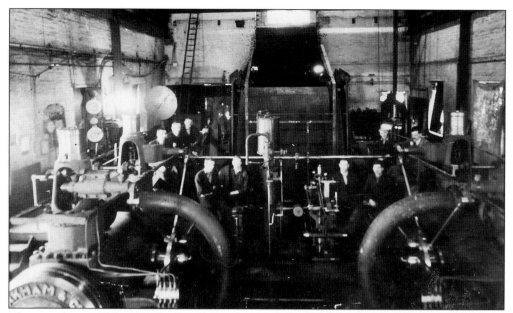

The completion of the installation of the new winding engine at the Victoria shaft was carried out between 2.00 pm on Friday 5 August and Saturday 13 August 1938. Mr Bert Beardmore, the colliery mechanical engineer, is on the extreme left.

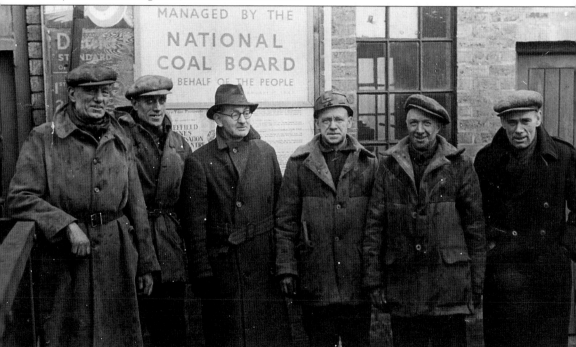

The Victoria Colliery shaft team, shortly after the nationalisation of the coal industry in 1947. The heavy coats were necessary when working in the cold and often very wet conditions encountered in the shafts during their inspection and maintenance. From left to right: -?-, Alfred Copeland, Jim Cook (deputy mechanical engineer), Bert Turner, Absy Ball, Arthur Hancock.

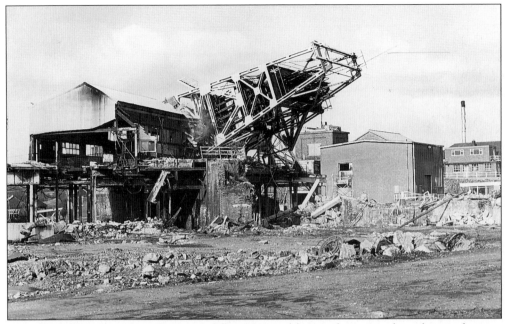

Victoria Colliery ceased production in July 1982, coal having been raised on the site for over 140 years. The end to deep mining in Biddulph finally came on 24 October 1983 after the Victoria shaft had been filled and capped and the winding heapstead over the shaft was demolished.

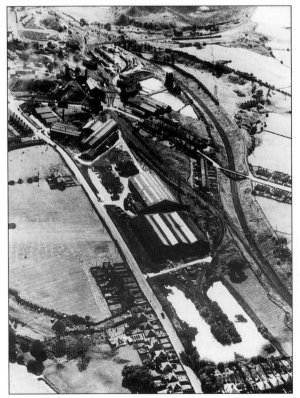

An aerial view of Victoria Colliery, c.1950. The colliery and site of the Biddulph Valley Ironworks' blast furnaces (demolished in 1935) is top left centre, south of Brown Lees Road. The site of the ironworks foundry and new forge, which became Cowlishaw Walker Engineering, stands left and centre between Brown Lees Road and the A527. The Biddulph Valley branch of the North Staffordshire Railway, which first carried coal from the developing colliery in 1860, runs top left to bottom right.

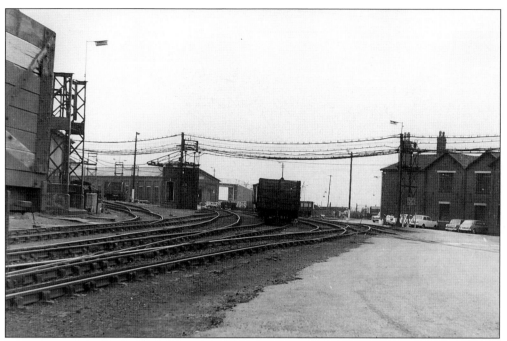

Looking towards Victoria Colliery from the direction of Brown Lees Road in 1967. The mechanical and electrical engineering workshops are in the centre and the colliery offices on the right.

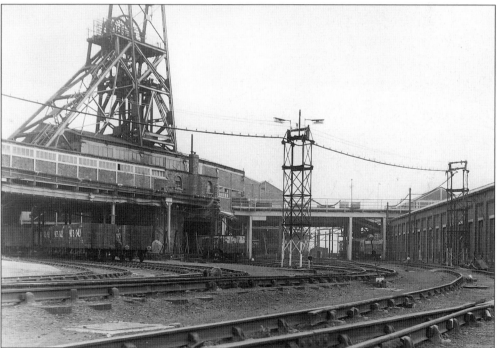

Moving further into the colliery yard, the Victoria shaft deepened from 130 to 486 yards in 1898-1901 is on the left and the mechanical and electrical engineering workshops on the right. The old blast furnaces were sited in the distant centre.

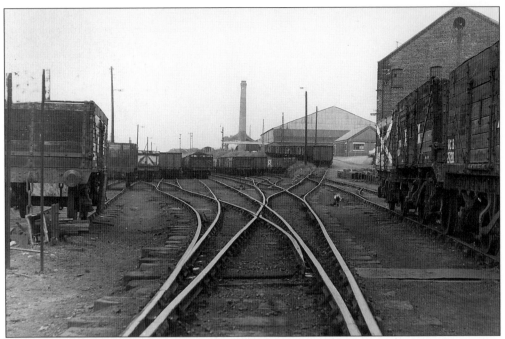

This view looks in the opposite direction from the Brown Lees Road towards the site of the ironworks' new forge. The original foundry building stands on the right. The railway track leads to Heath's Junction and the Biddulph Valley branch line.

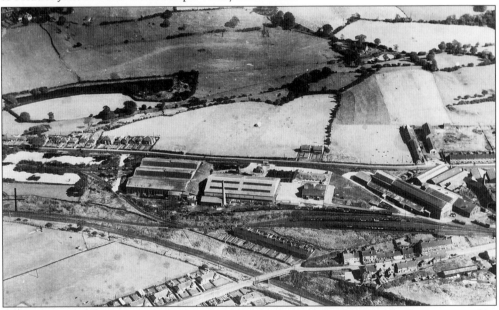

An aerial view of the site of the former Biddulph Valley Coal and Ironworks, here occupied by Cowlishaw Walker engineering. The railway line to the extreme left leaves the Biddulph branch line at Heath's Junction to enter the colliery sidings, passing the site of the new forge in the centre and the foundry on the extreme right, before crossing Brown Lees Road to enter the colliery yard. What remains of Knypersley Hall, the home of John Bateman, is in the top left corner.

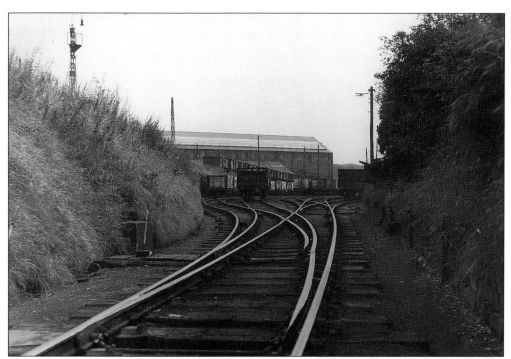

Entrance to the colliery sidings from Heath's Junction, the former ironworks foundry standing in the centre.

Heath's Junction, 1967. The railway line (right foreground) leads from Victoria Colliery – formerly Robert Heath's Biddulph Valley Coal and Ironworks – to where it joins the Biddulph Valley branch of the former North Staffordshire Railway.

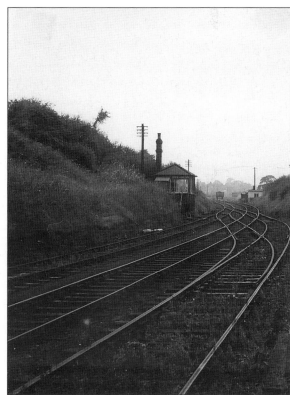

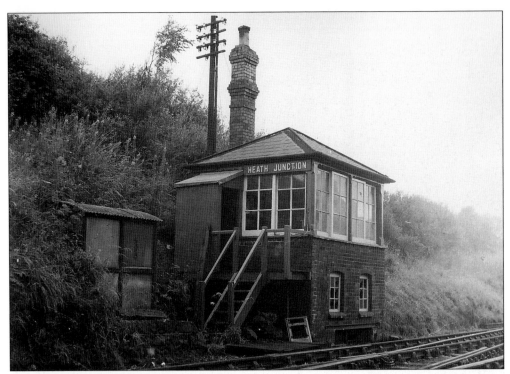

The signal box at Heath's Junction, 1967.

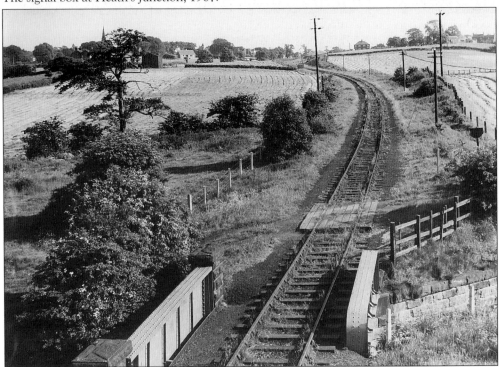

The Biddulph Valley Railway looking south towards Knypersley from the bridge, west of Wharf Road 1967.

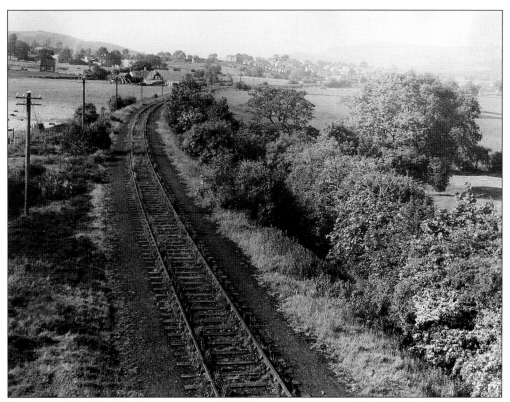
Looking in the opposite direction towards Biddulph station and Congleton.

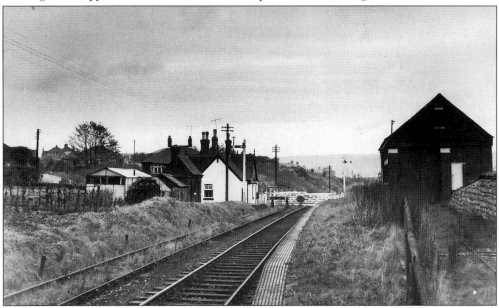
The site of Biddulph station in 1956. The main purpose of the Biddulph Valley branch line was to facilitate the development of coal mines along its route. Limited passenger services were run from 1864 until 1927 when the competition from road transport caused their stoppage. However, special trains continued to run at holiday times until the early 1950s.

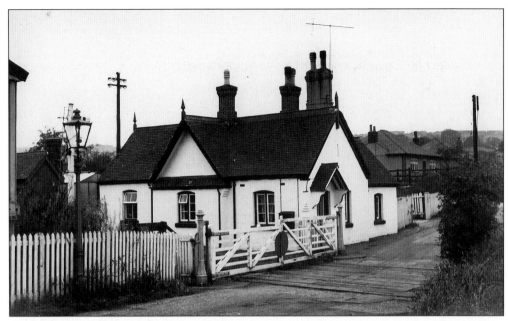

Biddulph station house and crossing 1964.

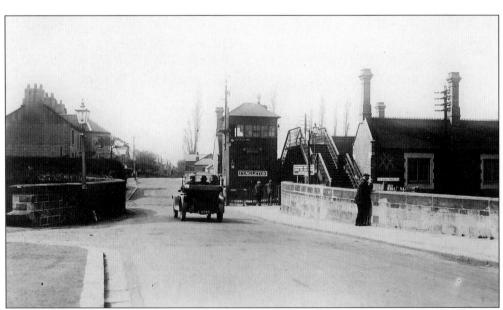

Congleton station, *c*.1930, on the London, Stoke-on-Trent, Manchester main line. Only three miles away, the station was frequently used by Biddulph people, especially after the ending of passenger services on the Biddulph Valley line in 1927.

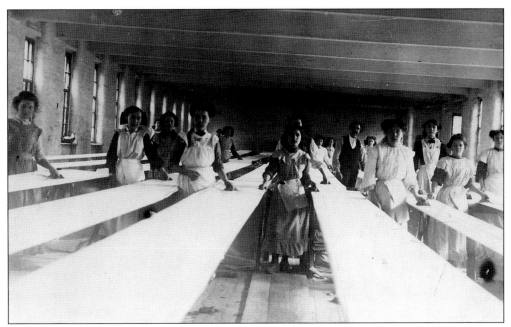

In the early 1900s six fustian mills were operating in Bradley Green (renamed Biddulph from 1930 onwards). The majority of men in Biddulph worked either in the coal mine or at the ironworks and the wages of the women who worked in the mills made an important contribution to the family income during the periods when their men folk were on short time working.

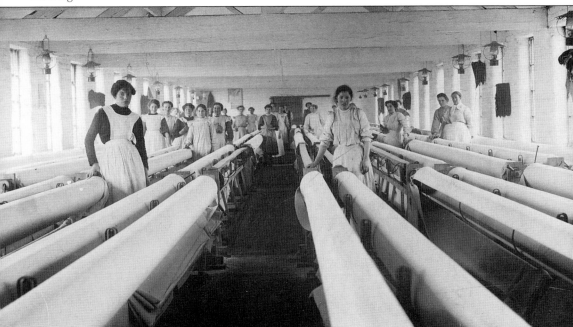

This mill on Biddulph Moor was a two-storey stone building, approximately 25 ft wide and 200 ft long, which has been considerably modified for its present use as a plastics factory. Between 1907 and 1936, fustian cutting was carried out there by the Jackson family of Congleton.

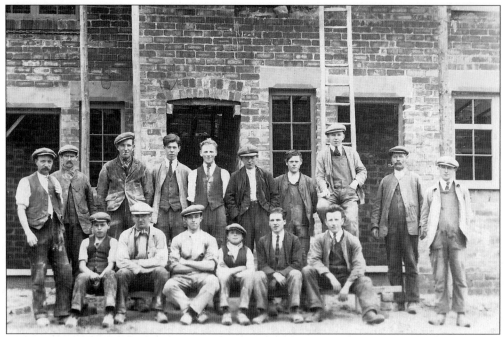

This is one of the building teams used on the construction of the Craigside estate, Biddulph Council's second venture into municipal housing in 1924. The contract to build Craigside Council estate (named after Dr Craig, the medical Officer of Health for Biddulph), was awarded with the proviso that the builder would use Biddulph men.

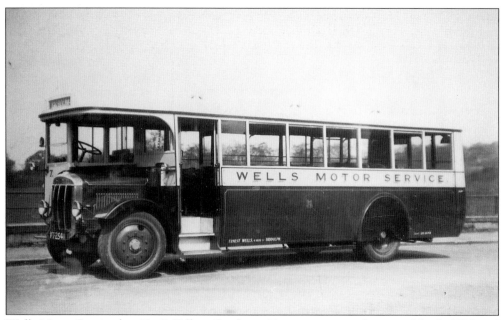

Wells Motor Service bus No.7, Tilling Stephens 32 seater, acquired new in March 1929 and withdrawn in 1934.

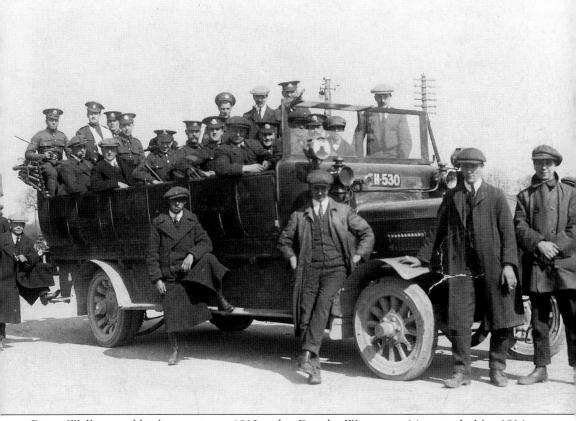

Ernest Wells started his bus service in 1913 with a Daimler Wagonette 14 seater. In May 1914 he acquired a new Durham Churchill 45 hp, 28 seater charabanc he named the *Flying Fox*. Here he is seen at the wheel when it had been commandeered to transport troops to Aldershot during the First World War.

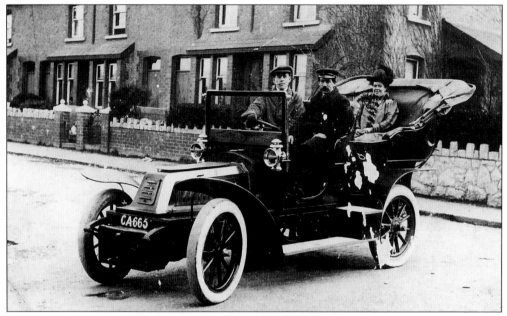

The young man driving the motorcar is Wesley Edwards, seen here acting as chauffeur to an unknown lady and gentleman.

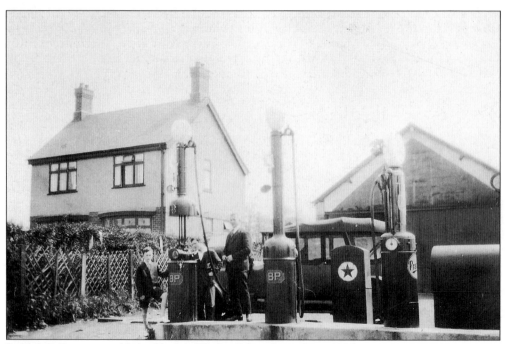

Biddulph Garage, established by Mr Wesley Edwards in about 1925.

Five
Recreation and Leisure

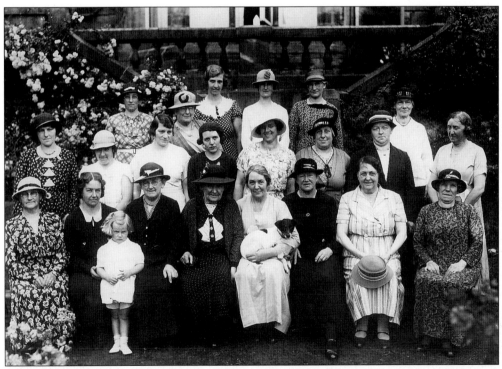

Ladies of the Moor House sewing group posing on the lawn in front of the house, c.1928. Back row, left to right: Mrs Ada Rowe, Mrs May Bennett, Mrs Winnie Weston, Mrs W. Mayer, Mrs Ester Mayer, Mrs Annie Mayer. Middle row: Mrs Hannah Heathcote, Mrs Jenny Knight, Mrs Fanny Chaddock, Mrs Lily Weston, Mrs Mabel House, Mrs Elizabeth Boon, Mrs Mary Pickford, Miss Boullen. Front row: Mrs Kitty Marsh, Mrs Laura Ball, Mrs Hannah Barker, Mrs Lucy Jane Lees, Miss Grace Lees, Mrs Edna Weston, Mrs Lily Hammersley, Mrs Bertha Brown.

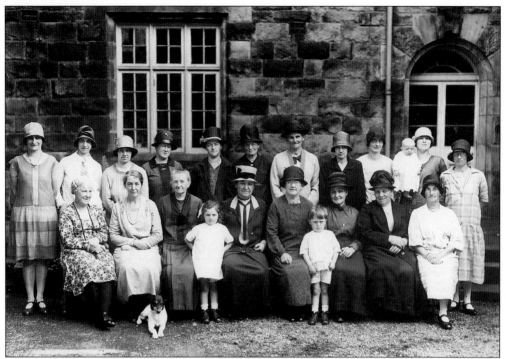

A sewing party at the Moor House, *c.* 1925, the home of Mrs Lucy Lees. Back row, left to right: Mrs Mabel Heathcote, Mrs Minnie Weston, Mrs Laura Ball, Mrs Edna Weston, Mrs Mary Pickford, Mrs Jane Gibson, Mrs Olive Whiston, Mrs Lily Gibson, Mrs Annie Finney, Mrs Anna Heathcote Cyril, Mrs Ada Rowe. Front row: Miss Jones, Miss Grace Lees, Mrs Jemima Brown, Mrs Lucy Lees, Mrs Hannah Barker, Mrs Betsy Weston, Mrs Hannah Brown, Mrs Kitty Marsh, Miss Lees's dog, Tinker. The children are Annie and George Rowe.

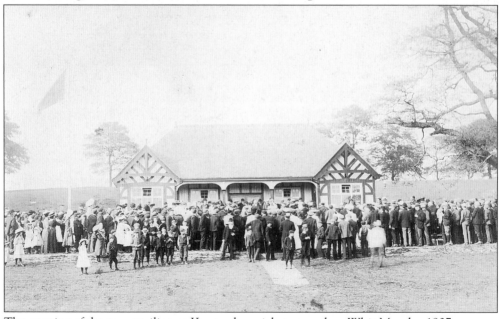

The opening of the new pavilion at Knypersley cricket ground on Whit Monday 1907.

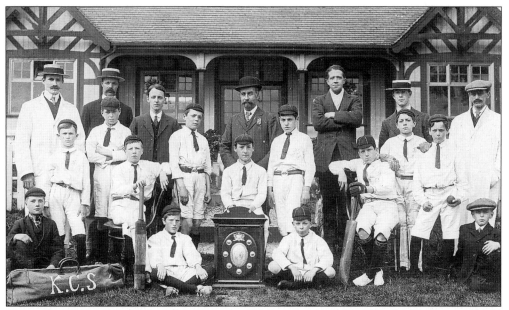

Knypersley Council School cricket team in 1914, winners of the Schools' Challenge Shield 1912 -14. The gentleman wearing the bowler hat is Mr William Lowe, the school's headmaster and the one on the extreme right is Mr Ted Awty, the wicket keeper for the Knypersley cricket team.

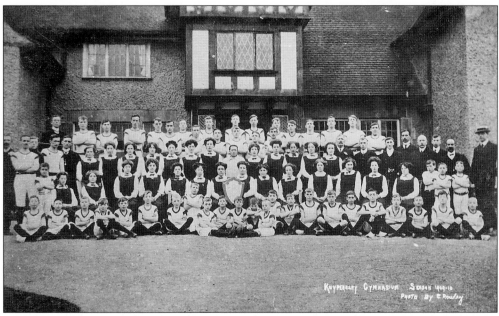

Members of the Knypersley Gymnasium Club in 1909 at Wayside, Park Lane, Knypersley, the home of the club's leader Mr Richard Harding, seen standing on the extreme right.

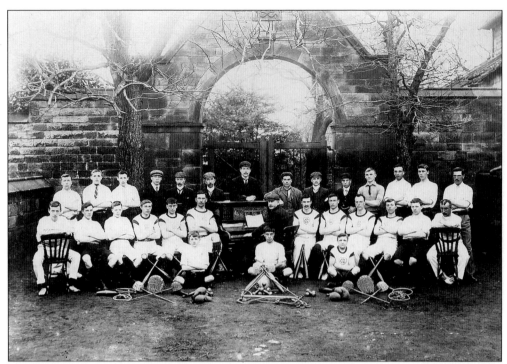

No details have been forthcoming about this men's sports club, seen at the entrance to the garden of Fairhaven, Knypersley. The gentleman resting his arm on the piano may be Mr George Harding, whose family lived at Fairhaven.

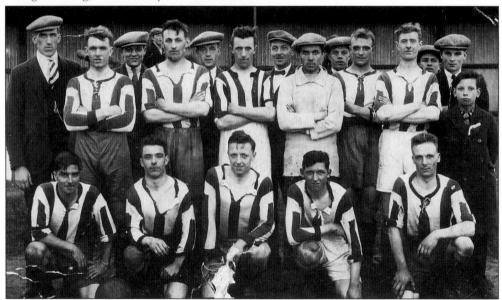

One of the many local football clubs in the area. Biddulph United were the winners of the Grosvenor Cup in 1930. The winning team was, standing left to right: Gordon Holland, Bill Lovatt, Jack Haydon, ? Goldstraw, Job Hickman, Joe Gidman. Kneeling: Bill Brindley, Edwin Poole, Frank Hancock, George Gibson, Sam Salt. George Gibson went on to become a professional player for Sunderland.

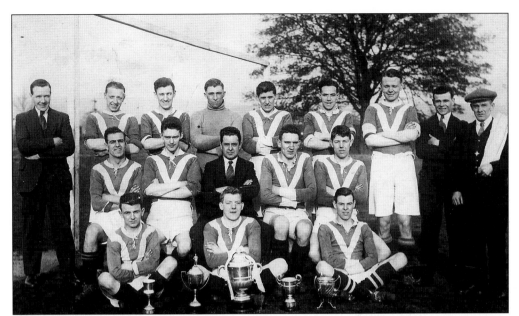

Although just over the border in Cheshire, this Dane-in-Shaw mill football team was mainly made up from men who lived in Biddulph. At this time in the early 1930s, a man's skill in a sport was a great advantage in helping him to find employment. Back row, left to right: -?-, Frank Hancock, -?-, Harry Brown, Frank Johnson, -?-, -?-, Albert Fitzgerald and father. Middle row: Norman Jolliffe, Joseph Bailey, -?-, John Walley, -?-. Front row: William Fitzgerald, James Pilling, Harry Shufflebotham.

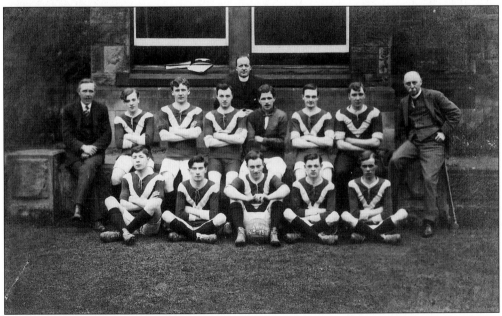

St Lawrence's Church football club 1915-6. Back row, left to right: Jonah Cotterill, Charles Rowe, William Cheetham, Edgar Brandreth, -?-, -?-, -?-, Robert Heath. Front row: -?-, Albert Weston, Cliff Embley, -?-, Jack Straw. At rear: the Reverend J.K. Cowburn.

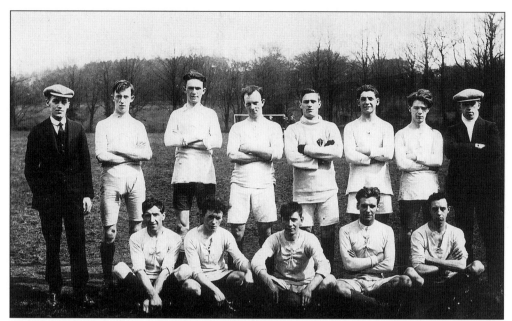

The Talbot Inn football club, Grange Road, *c.*1925. Back row, left to right: Frank Hancock, George Weston, Joe Bedson, Cliff Embley, -?-, Dennis Turley, Walter Crooks, -?-. Front row: Albert Prince, Thomas Nixon, -?-, George Hancock, -?-.

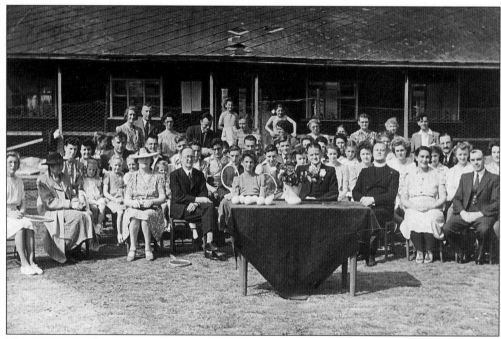

The reopening of St Lawrence's Recreation Ground by Counsellor E. Wingrove in 1946. The gentleman on the left of the table is Mr George Kay, the town clerk and the one on the right is the Reverend Jason Battersby, Vicar of St Lawrence.

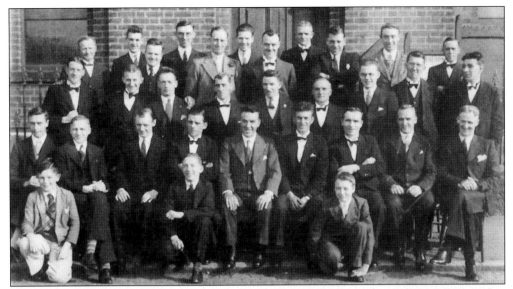

The Biddulph Male Voice Choir in 1938. The choir, founded in 1922, is still flourishing today. Back row, left to right: Jack Moss, Albert Ogden, Elliot Cooper, Leonard Dawson, Frank Wooley, Arthur Lancaster, Thomas Brown, Arthur Bracegirdle, Arthur Fradsome, Edward Bedson, James Baddeley. Middle row: James Scott, Leslie Potts, William Salt, George Higginson, Frederick Spragg, Harry Bridget, Alan Gaulton, Frederick Hadfield, Jack Slaney. Front Row: George Bedson, Frank Gaulton, George Boote, Thomas Collier, Thomas Johnson (conductor), Leonard Meir, Edward Collier, Samuel Salt, Jack Salt. Kneeling: Stanley Bentley, Harry Carthy, Reginald Salt.

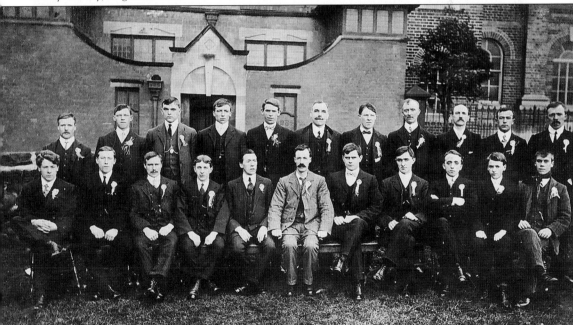

The Biddulph Moorland Glee Party seen at the front of the Primitive Methodist Chapel, Station Road. As yet no one has been able to name any of its members or give a date when the choir performed.

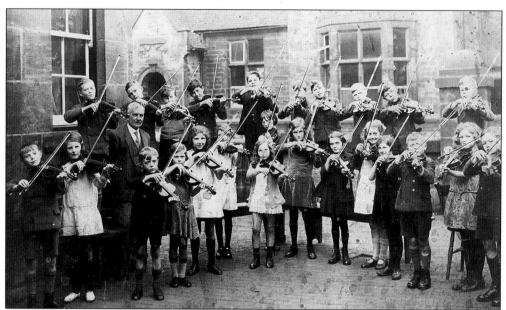

The violin class at Knypersley Council School, *c*. 1930, with their headmaster Mr George Lawton. The school in the background was built by Mr John Bateman of Knypersley Hall in 1849. The one to the left was built in 1911.

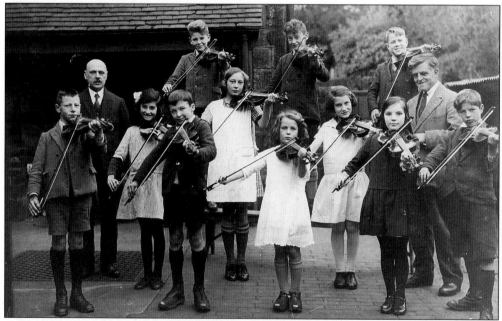

In the early part of this century Biddulph was a very musical community with numerous choirs and brass bands. Every school had its violin class, the pupils buying their own violins. These pupils are at St Lawrence's North Council School in 1931. Back row, left to right: John Bostock, Frank Maer, Ellis Mitchell. Middle row: Mr George Barker (peripatetic violin teacher), Miriam Close, Ethel Barber, Elizabeth Winterton, Mr William Shuttleworth (headmaster). Front row: Reginald Heathcote, Henry Shufflebotham, Lily Massey, Annie Stanway, James Eardley.

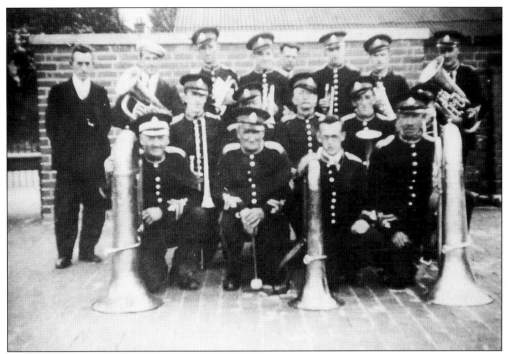

The Biddulph Moor Brass Band, *c*.1945, whose members were mainly drawn from three families. Back row, left to right: Percy Shufflebotham (music librarian), Bill Beech, Frank Fletcher, Fred Machin, Jim Bailey, Frank Machin, Leslie Ash, Tom Beech. Middle row: Jack Fletcher, Ben Fletcher, Harry Fletcher. Front row: George Beech, Arthur Bailey, Harry Beech.

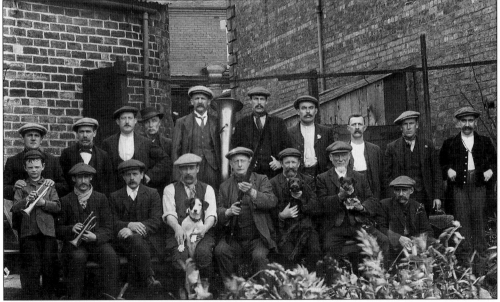

Standing where the present library is situated, then close to the Band Club and allotments, this group of man clearly show their leisure time activities: music, flower and vegetable growing and shooting. The gentleman wearing the trilby, Mr Malbon, and Mr Jack Cumberbatch on his right, were both keen bandsmen.

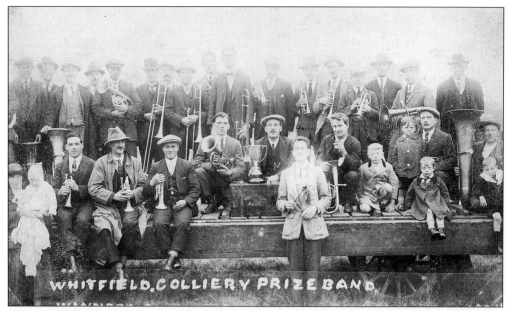

Many Biddulph men worked at Chatterley Whitfield Colliery and were members of its prize winning brass band. Back row, left to right: third Enoch Toole, fifth Frederick Cumberbatch, tenth Robert Evans. Front row: fifth Tom Collier, seventh Jack Evans, eighth William Owen, ninth Robert Stubbs.

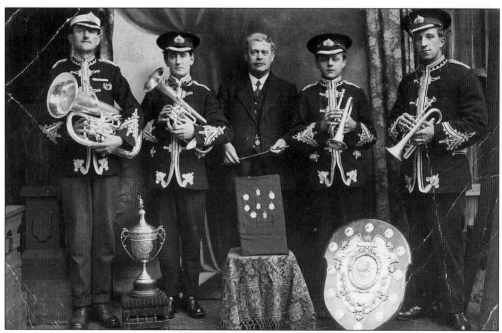

Biddulph Prize Band Quartet, *c*.1922. Left to right: John Evans, William Owen, Mr Fiddler (Yorkshire conductor), Horace Stubbs, George Carter, (steward of Band Club, Tunstall Road).

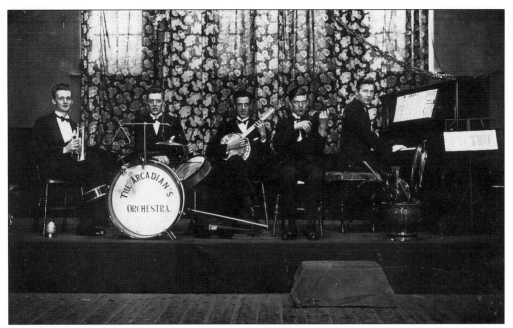

Biddulph also provided it's own music for the local dances which were held in the Conservative Club Gymnasium and the Public Hall. Here, in about 1935, the Arcadians are playing in the gymnasium. The pianist is Mr Bill Bentley and Mr Alf Copeland is playing the ukulele.

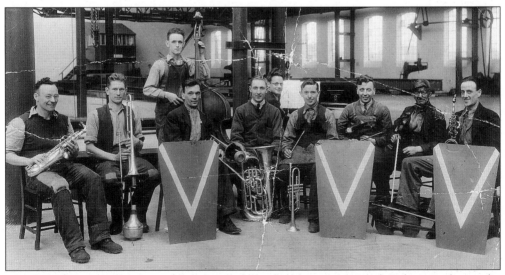

Band practice in a Cowlishaw walker fitting shop around 1945. Mr Frank Roberts is playing the double bass. The band leader, Alec Hilton, is sitting on his right and Alf Copeland is on the extreme right.

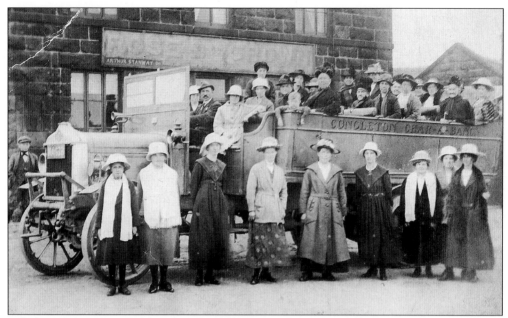

A ladies' charabanc outing starting from the Rose and Crown, Biddulph Moor, probably some time during the second decade of the twentieth century.

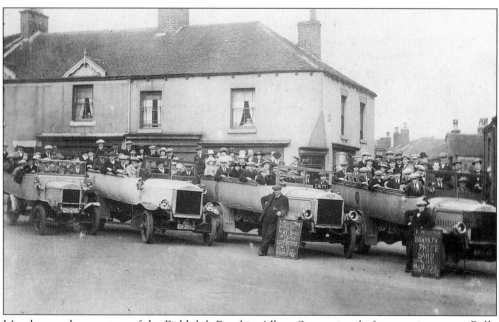

Members and supporters of the Biddulph Band in Albert Square just before starting out to Belle Vue, Manchester, to take part in the 1921 band competition.

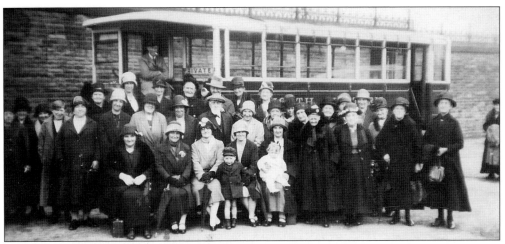

Ladies Co-operative outing to Southport, sometime in the early 1930s.

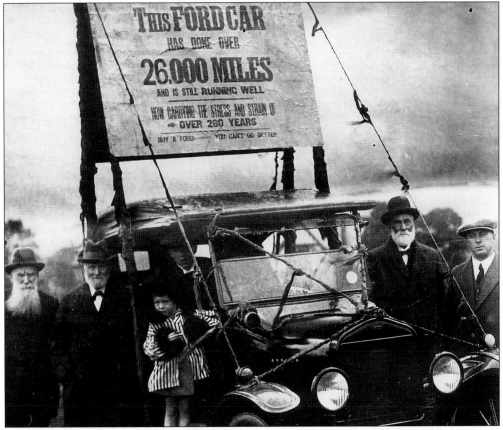

Probably taken on the old fairground, c.1925, the site of which was the fields on the north side of the Biddulph Arms, now occupied by Portland Drive. The combined ages of the three bearded gentlemen exceeded 260 years. They were, left to right: Mr John Frost (grocer, John Street), Mr Lawrence (Methodist Minister) and Mr Peter Rowley (draper, Albert Square). The gentleman on the right is Mr Colin Machin, builder, and the small boy is his son Donald, both of whom became the Chairman of Biddulph District in 1944-46 and 1969-70 respectively.

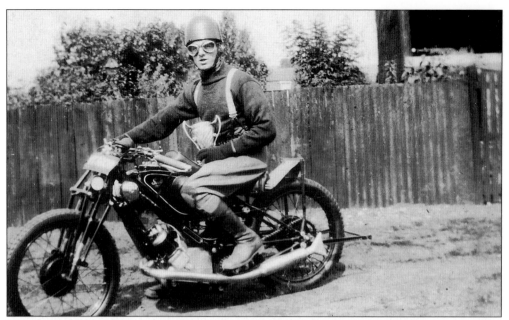

Mr Gordon Holland in 1930 aged 24, on his Scott Squirrel motorcycle, which he also used for grass track racing. Nine years later he became the Biddulph ambulance driver.

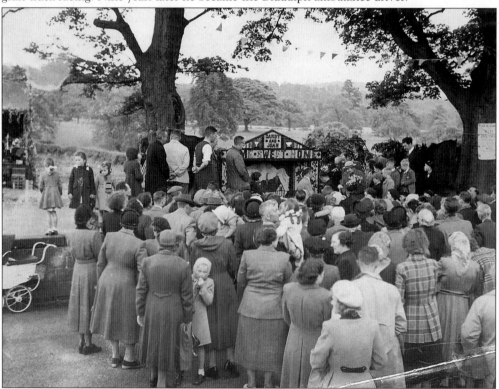

The opening ceremony of the well dressing, performed by Miss Lucy Lees of the Moor House, accompanied by the Council Chairman, Mr Leonard Poole and the Reverend J.D. Worsley, Vicar of St Lawrence's.

Guessing the weight of a load of coal.

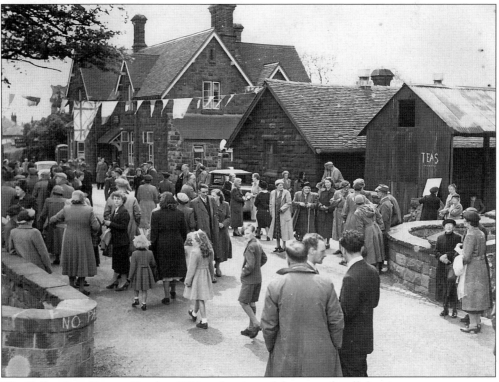

The Talbot Inn, Grange Road, *c.*1954 at the time of the annual well dressing.

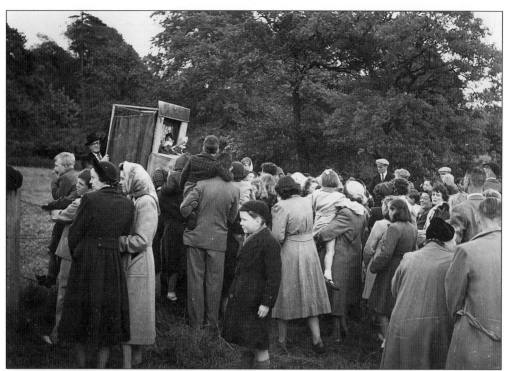

Punch and Judy - age old entertainment for children of all ages!

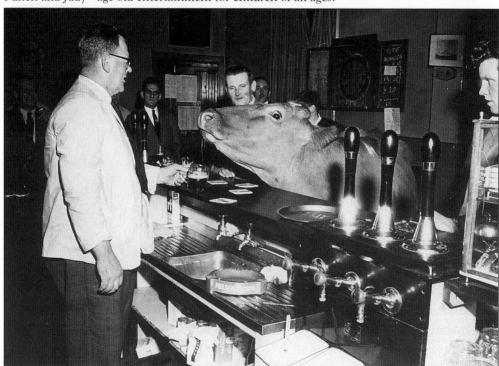

Mr Joseph Barker in about 1965, farmer, owner and landlord of the Talbot Inn, plays host to a local inhabitant.

Six

Men in Service

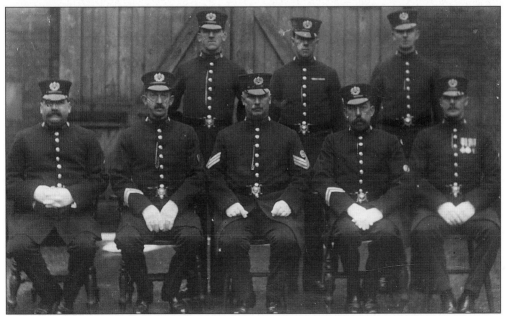

Biddulph Police Force, c.1928. Back row, left to right: Constables Stanton, Kelly and Chacket. Front row: Constables Beech and Hammersley, Sergeant Smedley and Constable Lloyd, -?-.

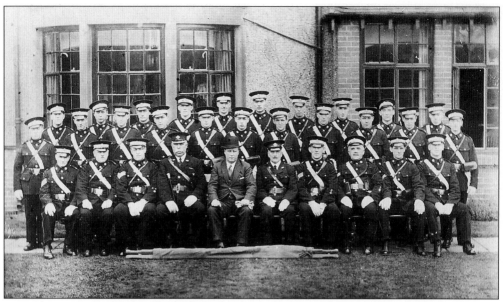

Biddulph St John's Ambulance Brigade in the garden of Dr John Murphy in the mid 1930s. Front row, left to right: fourth, 'Bobby' Chesterton, Dr Murphy, Frederick Powell, Leonard Bowden, ninth, Herbert Ogden, Frederick Bailey.

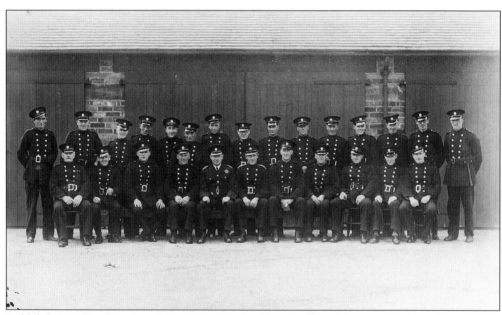

Biddulph Auxiliary Fire Service in 1942. The building in the rear was at the council yard in the Wharf Road where the fire-fighting equipment was housed. Back row, left to right: Frank Lancaster, Harold Boon, Arthur Dukes, Joseph Boon, George Brown, Wilfred Machin, Ellis Sherratt, -?-, Harry Knight, -?-, Harry Shufflebotham, Percy Turnock, Gilbert Shufflebotham, Harry Machin. Front row, left to right: Herbert Nixon, Colin Doorbar, William Lancaster, Jim Barker, Frank Millward, Frank Lancaster, Jack Machin, Sam Dean, Harold Boon, Arnold Anderton, Cyril Millward.

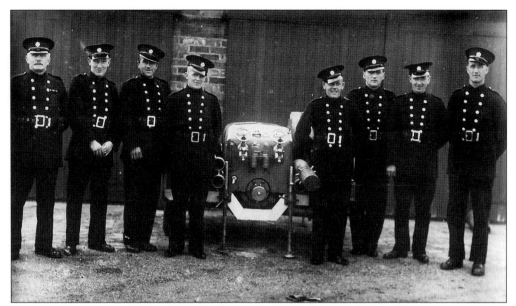

Biddulph fire team and fire tender, 1942. Left to right: Sam Dean, Arnold Anderton, Harold Boon, Arthur Dukes, Colin Doorbar, William Lancaster, Percy Turnock, Jack Machin.

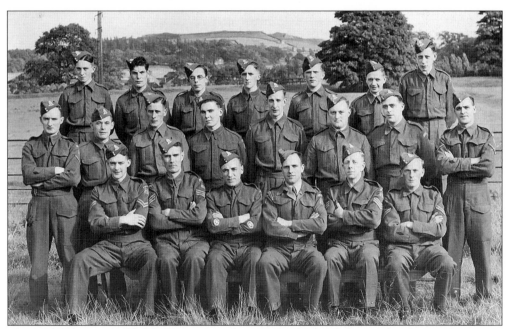

The 13th Platoon, Biddulph Home Guard, 1942. Back row, left to right: George Rowe, -?-, Derek Newton, Arthur Gibson, Derek Gibson, William Rogers, -?-. Middle row: Fred Gibson, William Beadle, -?-, Norman Finney, Daniel Hancock, Harold Botheras, George Carthy, Norman Jolliffe. Front row: Joseph Bailey, Frank Higgins, Harold Newton, John Wooley, John Ashton, Cyril Holdworth.

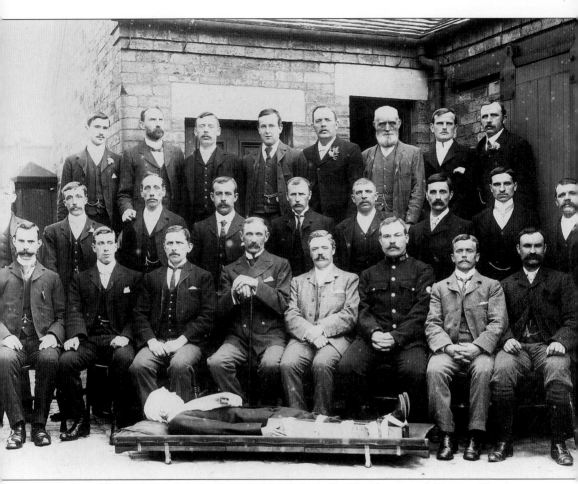

A first aid team in the yard of the Biddulph branch, Congleton and District Co-operative Stores. Dr Craig, the Biddulph Urban District Medical Officer of Health is fifth from the left on the front row.

Seven
Schools

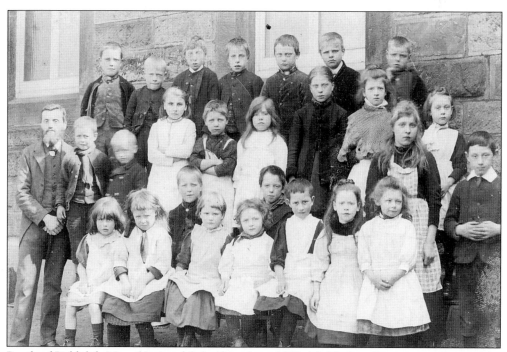

Pupils of Biddulph Moor National School in about 1892. Mr Herbert Reeves, master, is on the left and Miss Dale, mistress, is on the right.

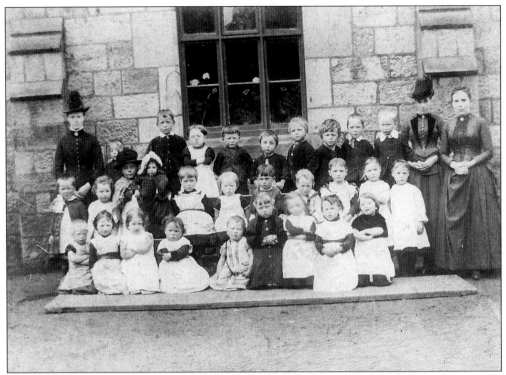

Infants at Biddulph Moor National School, *c.* 1891. The little girl in the centre of the middle row is Mary Ann Bailey and the boy in the back row to her left is Thomas Lawton.

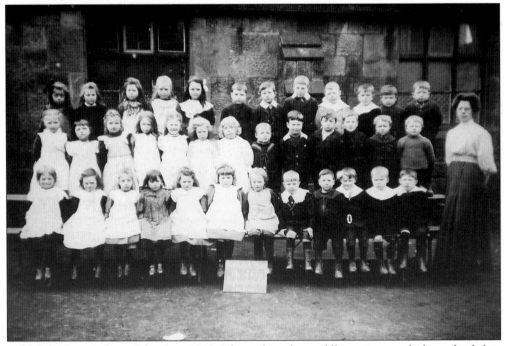

Biddulph Moor Infants School in 1910. The girl in the middle row, seventh from the left is Ellen Beech, who later became a teacher at the school.

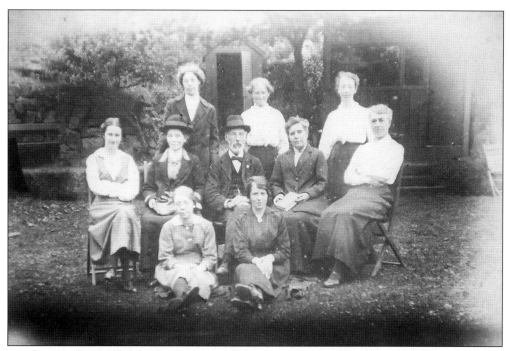

Teaching staff at Biddulph Moor National School in 1918, in the garden of Mr Reeves, master. Back row, left to right: Mrs Beech, Miss Lawton, Miss Reeves. Middle row: Miss Ray, Mrs Reeves, Mr Herbert Reeves, Miss Dale, Mrs Mitchell. Front row: Miss Ellen Beech aged fourteen, in her first year as apprentice pupil teacher, and Miss Nixon.

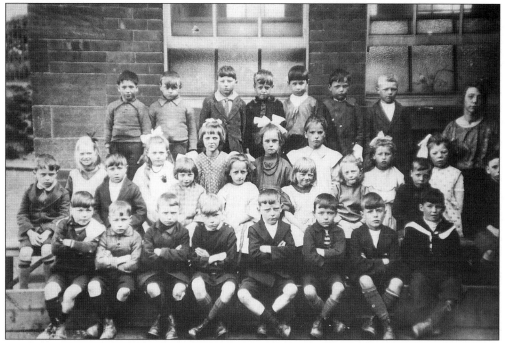

Biddulph Moor School, 1922. Miss Ellen Beech (who later became Mrs Brookes) with her first class after she had become an uncertificated teacher.

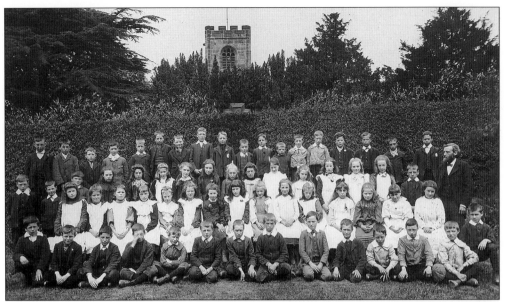

Pupils of St Lawrence's Church School at the turn of the nineteenth century. On the right is Mr Foulds Ryecroft Wilkinson, master of the school. In the background is the lych gate and church tower of St Lawrence.

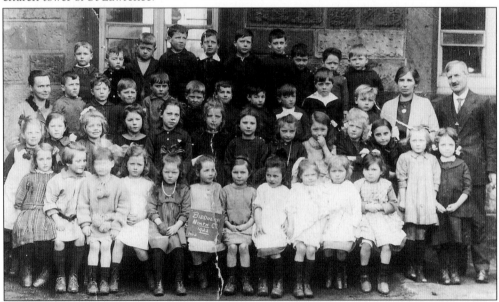

Biddulph North Infants School, 1922, (formerly St Lawrence's Church School). Back row, left to right: Phillip Warren, -?-, Roger Embrey, Frank Poole, Stanley Hancock, George Bestwick, Frank Finney, Harold Brown, Hedley Brown, Jack Bostock. Third row: Ted Finney, ? Chappel, Fred Chaddock, Jerry Cliff, Tom Shufflebotham, Hedley Hancock, Harold Cooke, Reg Pickford, Harold Cliff, -?-. Second row: -?-, Edith Bestwick, Eugene Hancock, Mabel Mellor, Ethel Purcell, -?-, ? Purcell, Francis Horton, Ruth Mayer, Lizzie Mitchell, Eve Marsh, Florrie Booth, Alice Hancock. Front row: Fanny Moss, Enid Cowburn, -?-, Emily Goldstraw, Marion Clewes, Betsy Barker, Lily Bestwick, ? Brown, Milly Worth, Doris Pimblot, Hilda Fithon. Teachers: Miss Oakes, Miss Dean, Mr Lawton (headmaster).

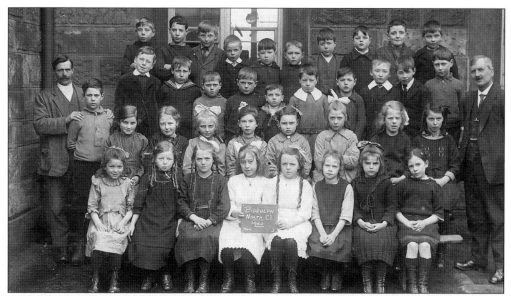

Biddulph North School, Class One, 1922. Back row, left to right: Fred Brown, Gordon Poole, Cyril House, Jack Massey, George Bostock, Philip Warren, Frank Bestwick, Tom Chaddock, Alfred Foden, Charles Gibson. Third row: William Moss, Jack Brown, Eric Wooley, Fred Wooley, Norman Brown, Tom Leese, Fred Lancaster, Job Shufflebotham, Tom Gilchrist, Norman Wright. Second Row: Jack Wright, Ethel Plant, Joyce Greenhalgh, Grace Barlow, Emma Fithon, Esther Mayer, Dorothy Kirk, Mary Mitchell, Harriet Mellor. Front row: Annie Howe, Jane Anne Clewes, Ethel Moss, Grace Marsh, Eva Poole, Ethel Clewes, Winifred Beech, Phyllis Dishley. Teachers: Mr Percival, Mr Lawton (head teacher).

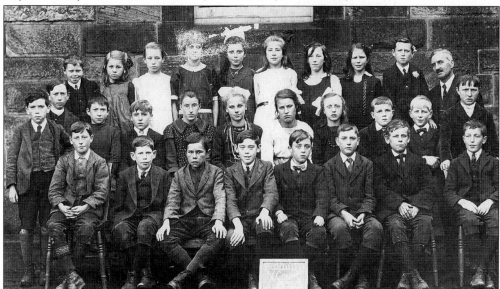

Biddulph North School, c. 1922. Back row, left to right: Eric Wooley, Alice Alcock, -?-, -?-, -?-, Mary Bostock, Jessie Chappel, Mabel Bestwick, Reginald Brown, Mr George Lawton (headmaster). Second row: -?-, -?-, Walter Chappel, -?-, Lily Boon, Ellen Plant, Mary Brown, Elsie Hulme, -?-, Jim Barker, Arthur Hulme. Front row: Harold Pimblot, William Bostock, Jack Bailey, Oswald Higgs, Harry Gibson, Robert Gibson, Joe Massey, Harry Crompton.

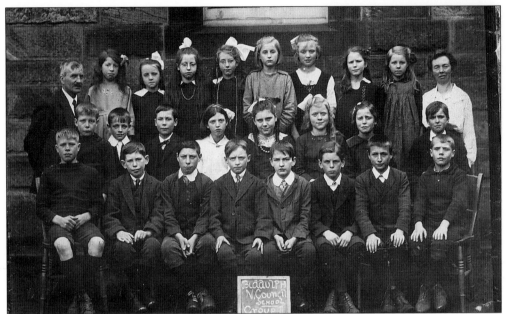

Biddulph North School, Group Two, c.1923. Back row, left to right: Harriet Leese, Eva Poole, Rhoda Poole, Millicent Poole, Mary Nixon, Mabel Bestwick, Alice Alcock, -?-. Second row: Frank Warren, Wilfred Hancock, Arthur Warren, Alice Gibson, Laura Finney, Alice Knight, Phyllis Bestwick, Sam Mitchell. Front row: Fred Mitchell, Bill Bostock, Fred Mellor, William Pickford, Cecil Hammersley, Tom Brookes, Charles Nixon, Len Moss. Teachers: Mr Lawton, Miss Cottrell.

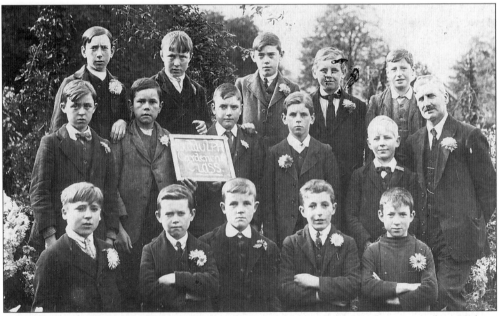

Biddulph North School gardening class, c.1923. Back row, left to right: -?-, Arthur Hulme, Oswald Higgs, Joe Massey, Harold Pimblot. Second row: Harry Gibson, Jack Bailey, -?-, Tom Brookes, Jim Barker, Mr George Lawton. Front row: Arthur Hambleton, Reg Brown, -?-, Harry Crompton, Walter Chappel.

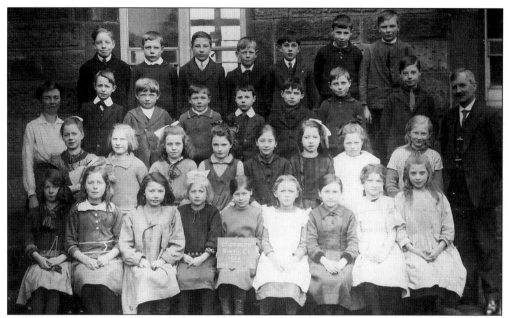

Biddulph North School, c. 1924. Back row, left to right: Dan Brown, Frank Warren, William Hargreaves, Joe Barker, Verley Pointon, Jack Poole, John Robert Gibson. Third row: Jack Marsh, John William Clewes, Tom Warren, Charles Marsh, George Mitchell, John Wooley, Harold Weston. Second row: Jane Mitchell, Joan Cowburn, Jessie Clewes, Jean Bailey, Helen Hancock, Rhoda Poole, Jessie Brown, Gladys Shufflebotham. Front row: Doris Leese, Phyllis Bestwick, Lilian Howe, Constance Nixon, Eileen Cooke, Agnes Pickford, Violet Marsh, Winifred Mitchell, Nellie Gibson. Teachers: Miss Cottrell, Mr Lawton.

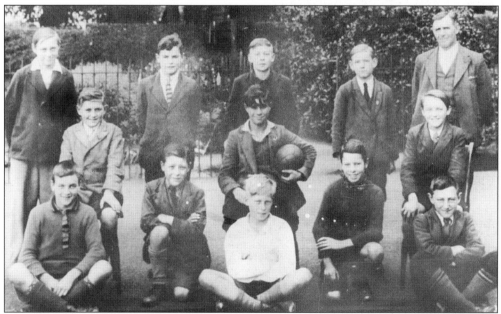

Biddulph North football team in 1930. Back row, left to right: Harry Patchett, William Beech, -?-, Harold Clowes, Mr A.C. Percival. Middle row: Howard Mayer, -?-, Edward House. Front row: Arthur Hancock, -?-, Joseph Smith, -?-, Henry Deaville.

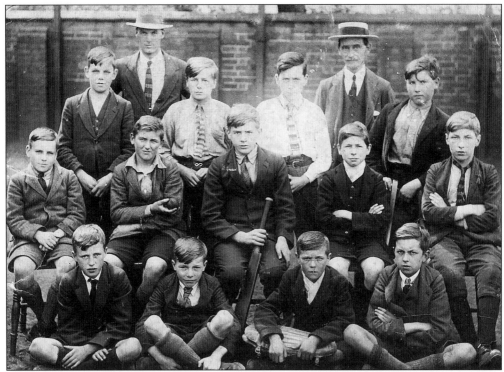

Biddulph Central School cricket team, 1929. Back row, left to right: Arthur Hodgkinson, Alan Frost, Walter Chapples, Ernest Wilshaw. Middle row: Tom Yates, George Gibson, Robert Butler, James Brockley, Horace Beech. Front row: Frank Awty, Douglas Haye, William Smith, Norman Wilson. Teachers: Mr Wilfred Hunt, Mr Clement Pollard.

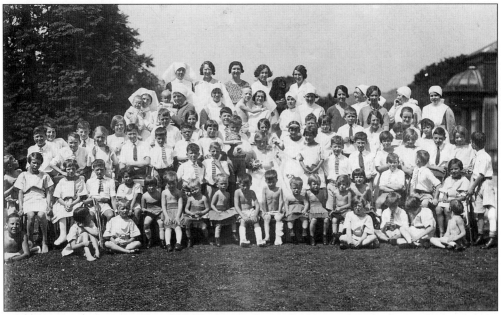

Children, teachers and nurses at the Grange Orthopaedic Hospital in the late 1930s.

Eight

Events

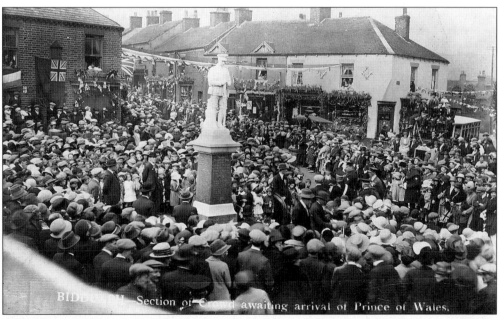

Albert Square, 12 June 1924. The people of Biddulph wait for the arrival of the Prince of Wales on his way to perform the official opening of the Staffordshire Orthopaedic Hospital at Biddulph Grange.

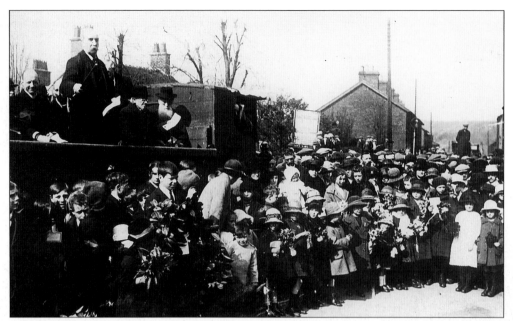

School children in Albert Square waiting for the arrival of the Prince of Wales on 12 June 1924. The occupants of the lorry from left to right are: Revd J. Cowburn, Mr William Lowe (schoolmaster), Mr Ralph Holland and Mr John Frost.

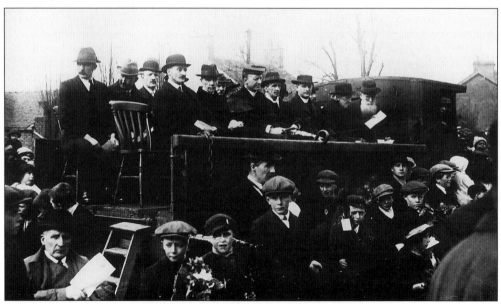

On the same day the gentleman third from the left, Mr Albert Sutton, was to become Chairman of Biddulph Council from 1925 to 1928.

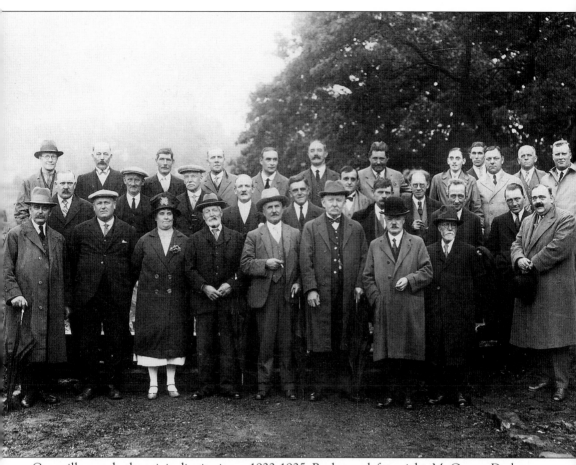

Councillors and other civic dignitaries, c. 1922-1925. Back row, left to right: Mr George Durber (council foreman), fifth Mr Fred Chaddock, seventh Mr Oswald Harding (assistant surveyor), tenth Mr Enoch Hancock, eleventh Mr Clews, Dr Murphy. Middle row: Mr Ben Unwin, Mr Isaac Beech, Mr Charles Reeves, Mr Albert Sutton, Mr Shuttleworth, (schoolmaster, Biddulph North), Mr Edward Linney (chairman of the Gas Committee), -?-, -?-, -?-, -?-. Front row: Mr Atkins, (gasworks manager), Mr Ernest Wells, Mrs Sally Linney, Mr Herbert Reeves (headmaster, Biddulph Moor), Mr George Lawton (headmaster, Middle School), Mr Thomas Shaw (Chairman Biddulph Council 1922-25), Dr Craig (Medical Officer of Health), -?-, Mr Shadrach Gibson (surveyor to the council).

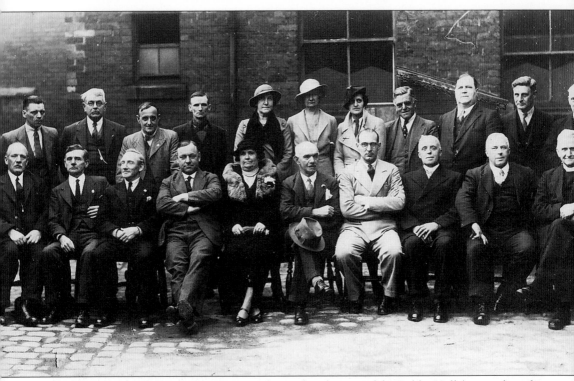

Councillors and other civic dignitaries in the yard at the rear of the Public Hall (situated on the corner of Wharf Road and High Street and demolished in 1966) during the chairmanship of Mr Joseph Casstles 1933-37. Back row, left to right: Mr Thomas Collier, -?-, Mr Thomas Linney, Mr Harry Sherratt, Miss E. Willatt (Middle School - girls), Miss E. Wharton (Middle School - infants), -?-, Mr E. Shuttleworth (North School - mixed), Mr R. Biddulph (Knypersley School), -?-, -?-. Front row: Mr Albert Sutton, Mr Horatio Whalley, -?-, Mr Enoch Hancock, Mrs Sally Linney JP, Mr Joseph Casstles (Chairman of the Council), Mr Moses Barker, Mr John Weston, Mr Colin Machin, Revd Myers Bridge.

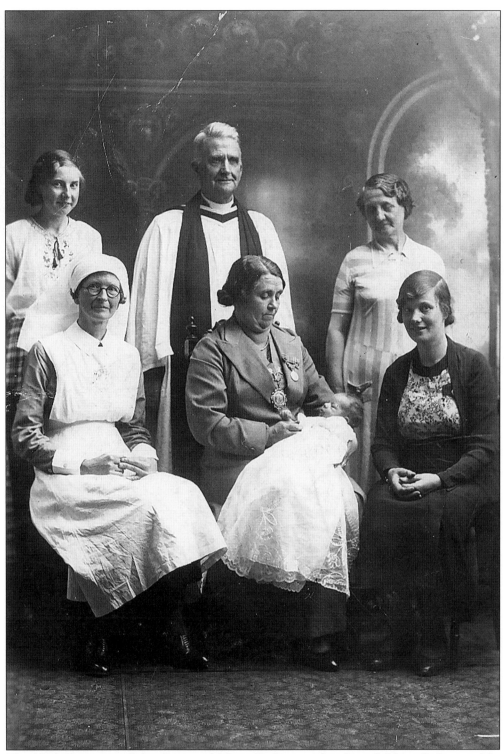

The 1936 Coronation Baby. Reverend Myers Bridge presides. Seated: Nurse Robinson, Mrs Sally Linney and baby Mary Goldstraw, Mrs Millicent Goldstraw.

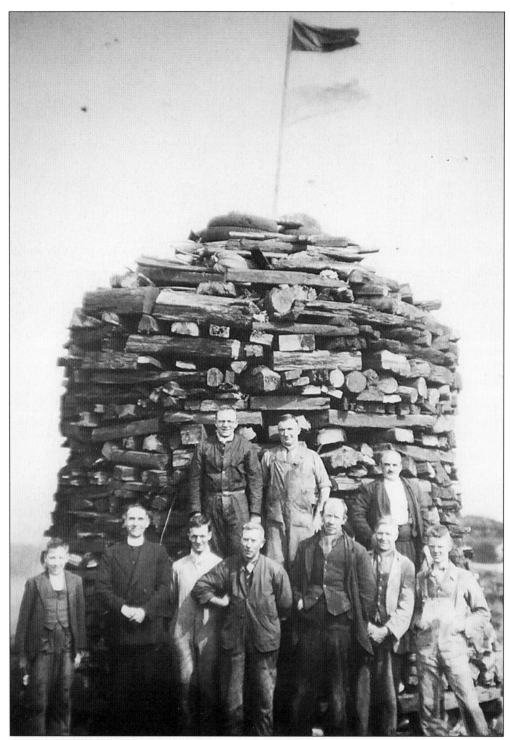

The 1936 Coronation Beacon on Bailey's Hill, Biddulph Moor. Back row, left to right: Jim Brown, William Nixon, Edward Plant. Front row: Harold Brown, Revd Frederick Fletcher (Rector of Biddulph Moor), William Hall, Bill Finney, Harry Beech, -?-, Cyril Lancaster.

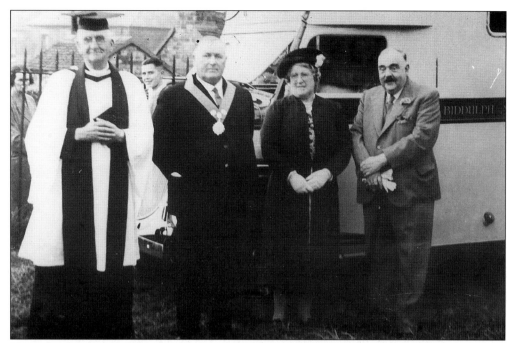

The presentation of the gift of an ambulance given by Mr Ernest Wells to the people of Biddulph in 1939. Left to right: Reverend Myers Bridge, Mr Ernest Wells (Chairman of the Council), Mrs Wells and Shadrach Gibson (Council Surveyor).

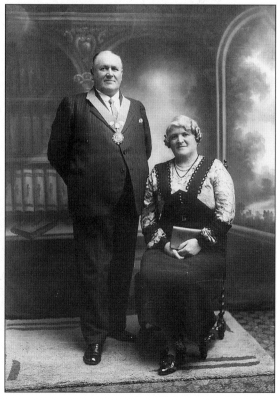

Mr Ernest Wells on becoming Chairman of Biddulph Council in 1938.

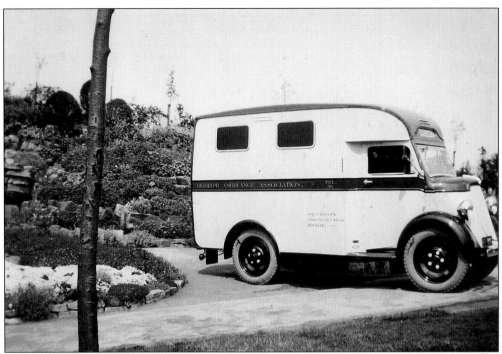

The Biddulph ambulance photographed in the Burslem Park shortly before its presentation to the Biddulph Ambulance Association.

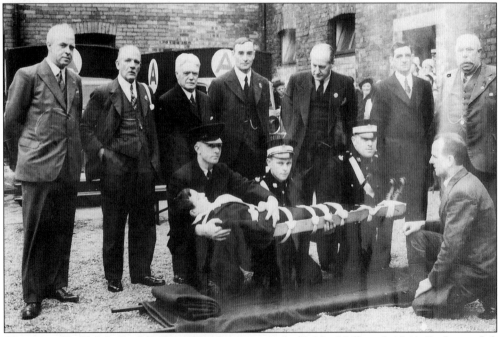

Opening of Biddulph Civil Defence Headquarters in the Public Hall yard, 1941. Back row, left to right: William Sherratt, Albert Sutton, Dr Craig, Frederick Chaddock, -?-, Herbert Ogden (Superintendant St John's Ambulance), Herbert Chesterton. Front row: Gordon Holland, Wilfred Brough, Ernest Pointon, Egbert Baddeley, Ronald Baddeley (stretcher).

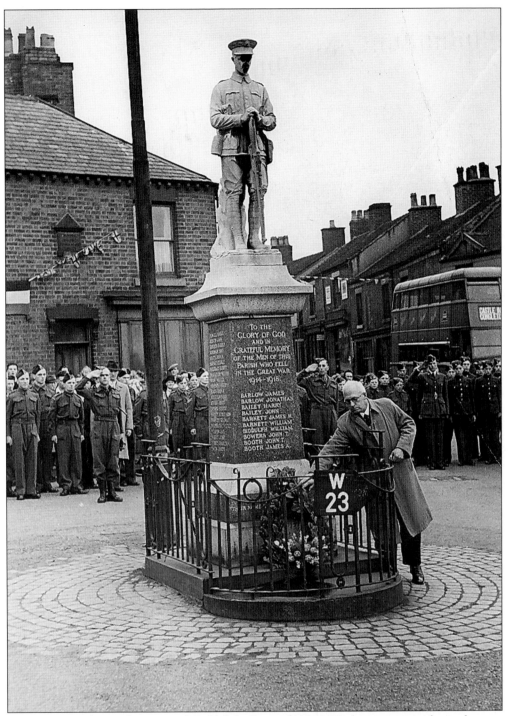

Mr Colin Machin, Chairman of Biddulph Council 1944-46, laying a wreath at the war memorial in Albert Square. At the rear on the left are the Army Cadets headed by Lieutenant Robinson, the School Attendance Officer and on the right, the Air Training Cadets.

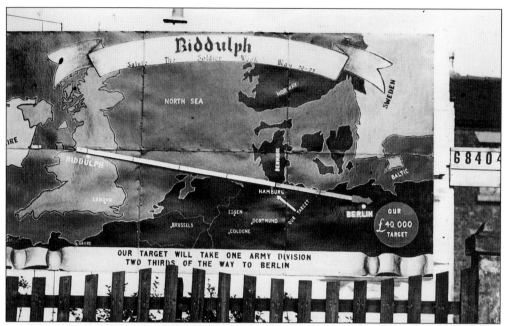

Raising money during the Second World War when £40,000 would take a whole army division two thirds of the way to Berlin.

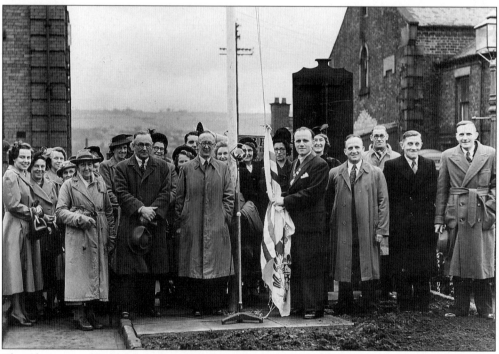

The Chairman of Biddulph Urban District Council, Mr H.L. Bailey, raising the flag at the start of Biddulph Savings Week in October 1949. Mr G.L. Kay, Clerk to the Council, is to his left. In the background the Public Hall is on the right and the Unionist Club on the left.

Nine
Societies

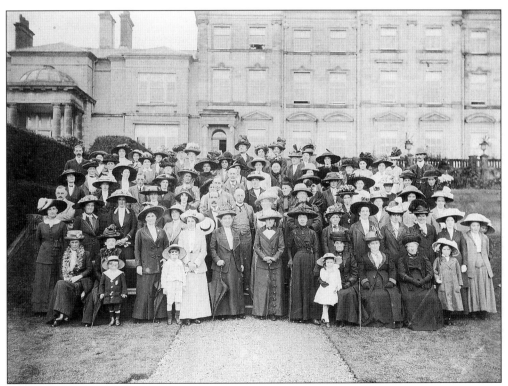

A group of ladies at the Grange, *c.* 1906. The lady in the front row with the unfurled umbrella is Mrs Lucy Leese of the Moor House. To the left is her daughter Miss Grace Leese, and the gentleman to her right is Mr Robert Heath of the Grange.

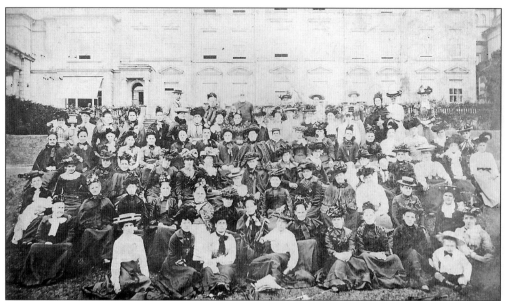

A gathering of what may be the Female Friendly Society in about 1900, on the lawn at the front of the Grange. The gentleman at the rear wearing a straw boater is Robert Heath, who rebuilt the Grange in 1897 after it was destroyed by fire. The gentleman with the beard is the Reverend Brodie, the Vicar of St Lawrence, Biddulph, from 1892 to 1906.

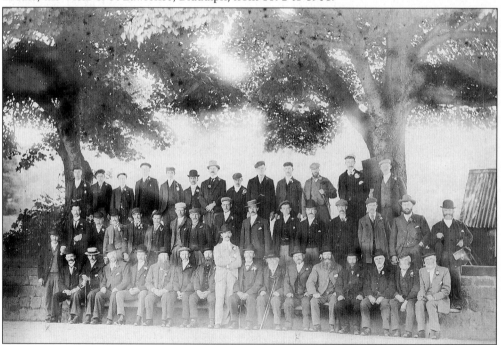

A group of men opposite the Talbot Inn, Grange Road, in about 1900. Unfortunately the reason for the gathering is not known. Back row, left to right: third Samuel Bailey, fourth James Bailey, tenth James Brown, twelfth Frank Leese. Centre row: fourth Fred Hilditch, seventh William Bailey, twelfth William Hackney. Front row: sixth William Bailey, ninth Joseph Casstles, twelfth William Pickford, sixteenth Enoch Brown.

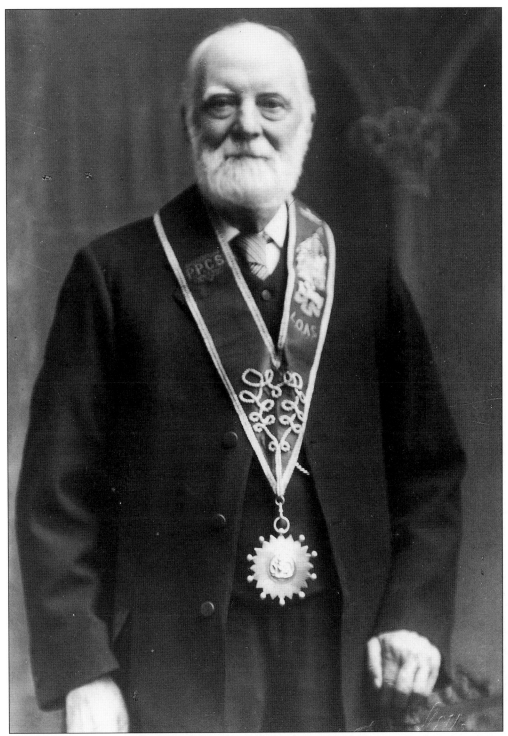

Mr John Weston is seen here wearing the regalia of the past President of the Royal Order of Ancient Shepherds. He was the father of John 'Granker' Weston, who is seen standing at the front of his grocers shop at No. 42 High Street, on page 38.

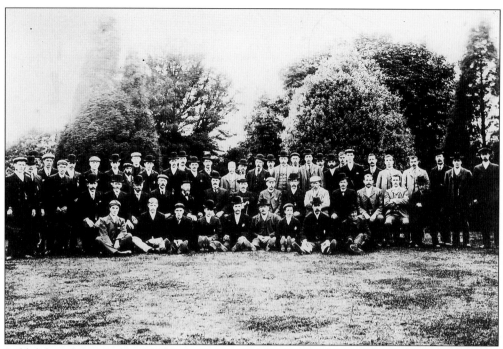

Biddulph and Knypersley Oddfellows Society in 1896, on the lawn at the northern entrance to the Grange. Robert Heath, wearing a cap, is in the centre of the middle row.

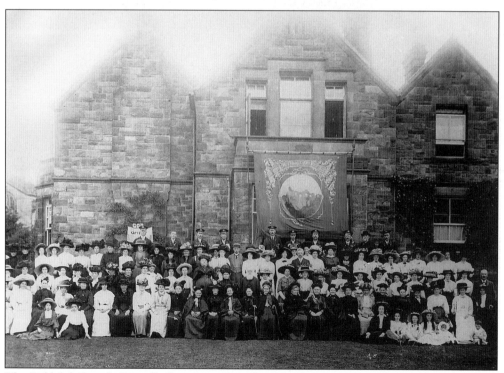

The Biddulph Female Friendly Society at the side of St Lawrence's Vicarage in the first decade of the twentieth century. The church is on the extreme left.

Ten

Church and Chapel

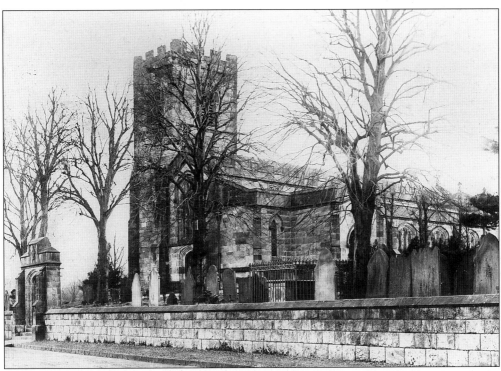

The earliest recorded incumbent of Biddulph Church was Edwardus de Biddulph who was the rector around 1190 AD. Between about 1391 and 1536, the Abbots of Hulton were in charge of Biddulph and it was during this period that Grange Farm came into being. The church was substantially rebuilt around 1534 and again in 1834. It is the area surrounding the church that gave Biddulph its name. The town now called Biddulph was, until 1930, named Bradley Green on the Ordnance Survey maps of that date.

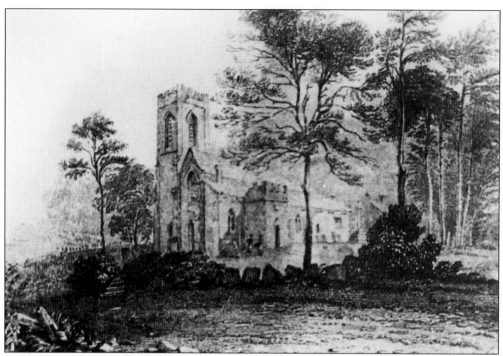

St Lawrence's Church, Biddulph, two years before it was rebuilt in 1834. The original Church House Inn, a low building of ancient appearance, later replaced by one of red sandstone, is standing east of the church. In 1874 the Church House was demolished and replaced by the present Biddulph Arms.

Biddulph Parish Church
(S. LAWRENCE).

Original Church destroyed by the Danes, re-built 12th century—Tower, upper part, 16th century—Church chiefly re-built, 1833.

Registers dating from 1558.
1st Vicar, Nicholas Whilock, 1558-77.

Once a Chantry Chapel under Monks of Hulton Abbey (Staffs.), granted to them in a deed (extant) under Great Seal of Richard II., 1390.

First Rector, noted, Odo le Chapeleyn (Temp. Richard I).

Heath Memorial (by Noble).
Several Ancient incised Tomb Slabs under South windows, with Crosses, Swords, and Battle-axes, 600-900 years old.

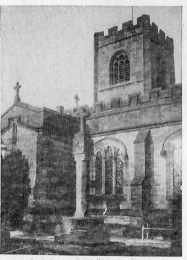

South Porch and Old "Weeping Cross."

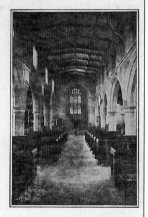

Interior looking East.
Clerestoried Nave, Chancel, Two Aisles. Style: Early English. Alabaster Table Tomb, 1640. Crusader's Helmet and Crest, Gauntlets, and Spur.

With Rev. and Mrs. H. J. Cossar's Sincere Good Wishes for Xmas and New Year, 1909-10.

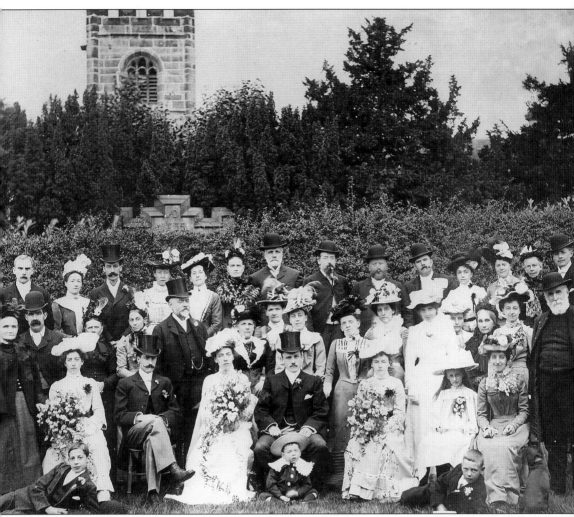

A rather splendid Victorian wedding at the Biddulph Parish Church sometime during the tenure of the Reverend David Brodie (front right) who was the vicar between 1892 and 1906.

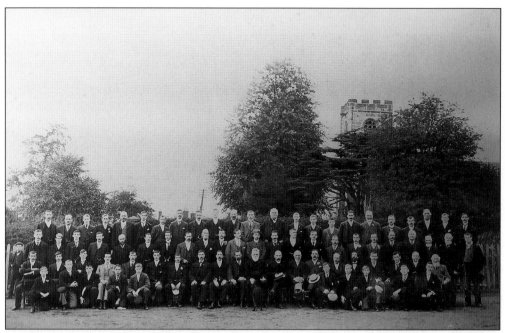

St Lawrence's Church men's Bible class, c. 1905. Back row, left to right: fifth William Pickford (snr), twentieth Frederick Hilditch. Middle row: fourth Arthur Weston (snr), eleventh James Smith (snr), twelfth Robert Heath, fifteenth James Stanway (snr), sixteenth James Holland, twenty-second Samuel Waller, twenty-third Samuel Pointon. Front row: fourth Joseph Casstles, elventh Reverend D. Brodie, fourteenth William Walley, sixteenth Edwin Hancock, seventeenth John Holland. Kneeling: second Harold Moss, third William Pickford (jnr), seventh Samuel Bailey.

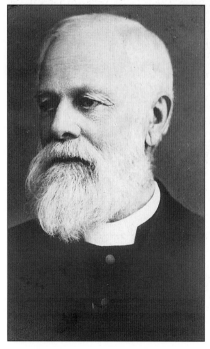

Roland Bateman (1840-1916), the second son of James Bateman, became the Vicar of Biddulph in 1906 after returning from India where he had been a missionary from 1868 to 1902.

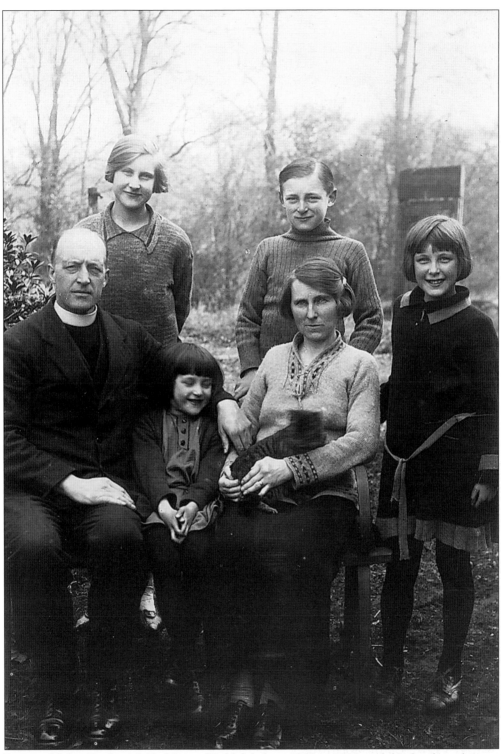

Reverend John Cowburn MA, Vicar of Biddulph from 1915 to 1926, with his family in the year that he left the parish.

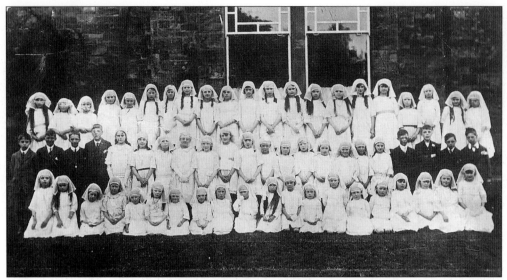

St Lawrence's Church Sunday school anniversary, 1925. Back row, from left to right: Millicent Bailey, Agnes Pickford, Mabel Parr, Ethel Plant, Grace Barlow, Molly Hazeldine, -?-, -?-, -?-, Elizabeth Brough, Norah Hulme, Mary Brown, Constance Booth, Elizabeth Brough, Ruth Barlow, Dora Dale, Millicent Roberts, Louis Moss, ? Richards, Hilda Bailey. Centre row: Bruce Charlesworth, George Gibson, George Parr, -?-, ? Booth, Hannah Moss, Gladys Clewes, Nellie Walley, Hilda Haydon, Mabel Salt, Lauretta Bowden, ? Richards, Cathleen Brown, Jane Anne Clewes, Gertrude Byatt, Blanch Lowe, George Hulme, -?-, Harry Shallcross. Front row: ? Richards, Nora Bradbury, -?-, -?-, -?-, -?-, Georgina Pickford, ? Thorinton, Grace Pointon, -?-, -?-, ? Thorington, -?-, -?-, -?-, Emma Brough, Flossie Bailey.

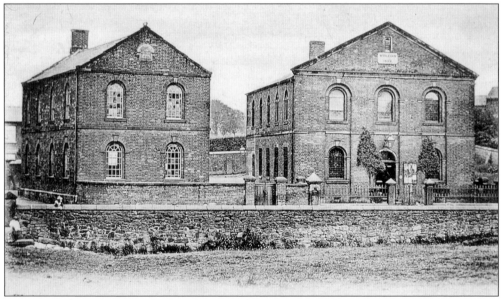

Station Road Wesleyan Methodist Chapel in the early part of the twentieth century. A chapel was first built on the site in 1833, this larger building being erected in 1856. It was finally closed in 1977.

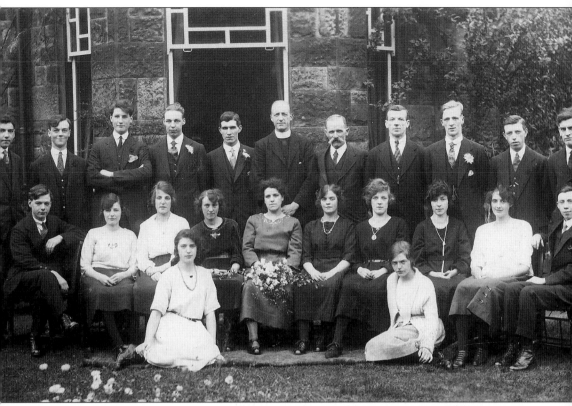

St Lawrence's Church choir, *c.*1920. Back row, left to right: Alec Wright, Tom Brown, Bill Hazeldine, Jeffrey Leigh, Jess Wright, Revd John Cowburn, Joseph Higgs, Richard Weston, Jack Salt, John Arthur Weston, William Hall. Front row: Walter Crooks, Miss Spragg, Miss Salt, Miss Whiston, Mrs Jess Wright, Hall (?), Salt (?), Crookes (?), Miss Elizabeth Wilshaw, Jeffrey Whiston. Kneeling: Miss Higgs and Miss Clewes.

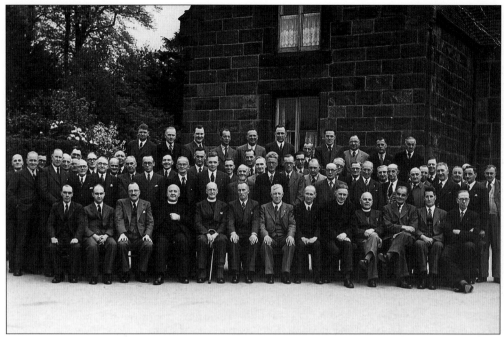

St Lawrence's Church Men's Society, 1954, in front of the school house, which stands alongside the church school built by Robert Heath in 1874. The gentleman with the walking stick is the Reverend John Cowburn who was vicar from 1915 to 1926 and is officiating while awaiting the arrival of a new vicar to the church.

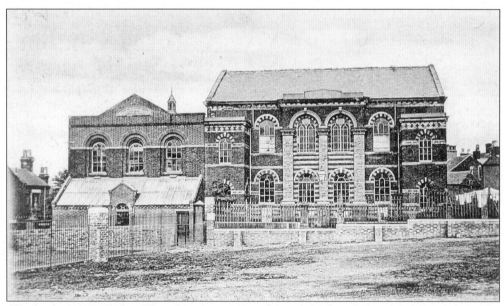

The Primitive Methodist Chapel in Station Road (named Chapel Street up to 1896), in the early 1900s. Although this building was erected in 1880, the baptismal registers were started in 1856.

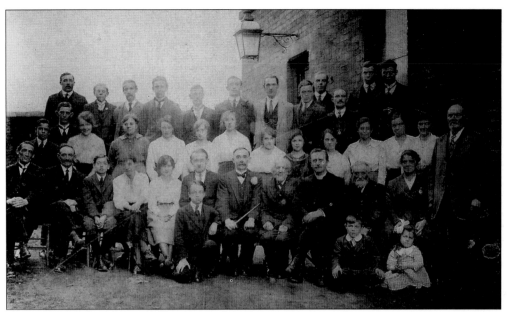

Station Road Wesleyan Methodist choir, *c.* 1920. Back row, left to right: Ambrose Sherratt, Ernest Sanderson, Joseph Turner, Harry Roberts, George Higginson, Jack Roberts, William Bailey, Arthur Morris, Arthur Sanderson, Harry Bridget, Jim Green, Philip Green. Middle row: Frank Gibson, Harry Parkinson, Mary Whitehurst, Mary Sanderson, Louise Poole, Phyllis Bailey, Lisa Anne Bailey, -?-, Patty Sherratt, -?-, Mabel Sanderson, Elizabeth Webb, Florence Hall. Front row: Jack Roberts, Tom Roberts, Bert Roberts, Lisa Bailey, Mrs Bailey, Philip Bailey, Ted Roberts, Ralph Holland, W.A. Unsworth (minister), Archibald Boot, Mrs Hall, Mr Hall. Kneeling: Len Parkinson, Ellis Sherratt, Hilda Hall.

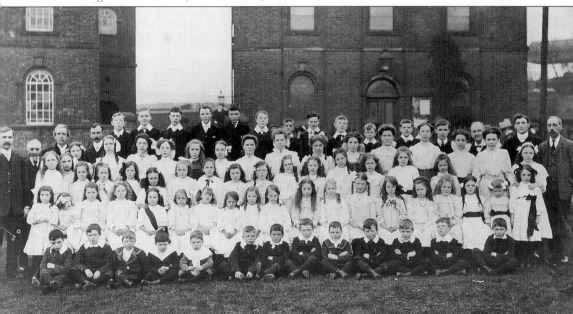

Children standing at the front of Station Road Wesleyan Chapel, probably at the time of the Sunday school anniversary in the early part of this century.

Acknowledgements

I wish to thank the following Bidolfians for the loan of the photographs and postcards included in this book: *The Biddulph Chronicle*, Biddulph Grange Garden, National Trust, Miss O. Beech, Mrs E. Brookes, Mr T. Gibson, Mrs A. Gregory, Mr S. Hall, Mr J. Hancock, Mrs M. Hart, Mr G. Holland, Mr J. Holland, Mrs G. Machin, Mr W. Machin, Mrs R. Morris, Mrs D. Palmer, Mr J. Sherratt, Mrs Sherwin, Mrs G. Shufflebotham, Mr H. Shufflebotham, Miss A. Stanway, Mrs A. Turnock, Mrs J. Wood, Mr W. Wooley and Mr V. Yates.
All the royalties from this book will be given to the Biddulph Grange Garden of the National Trust and towards the establishment of a Biddulph Heritage Centre.